Decorative
Painted Projects
for the Home

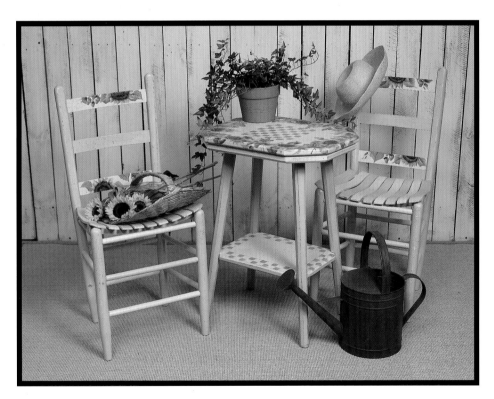

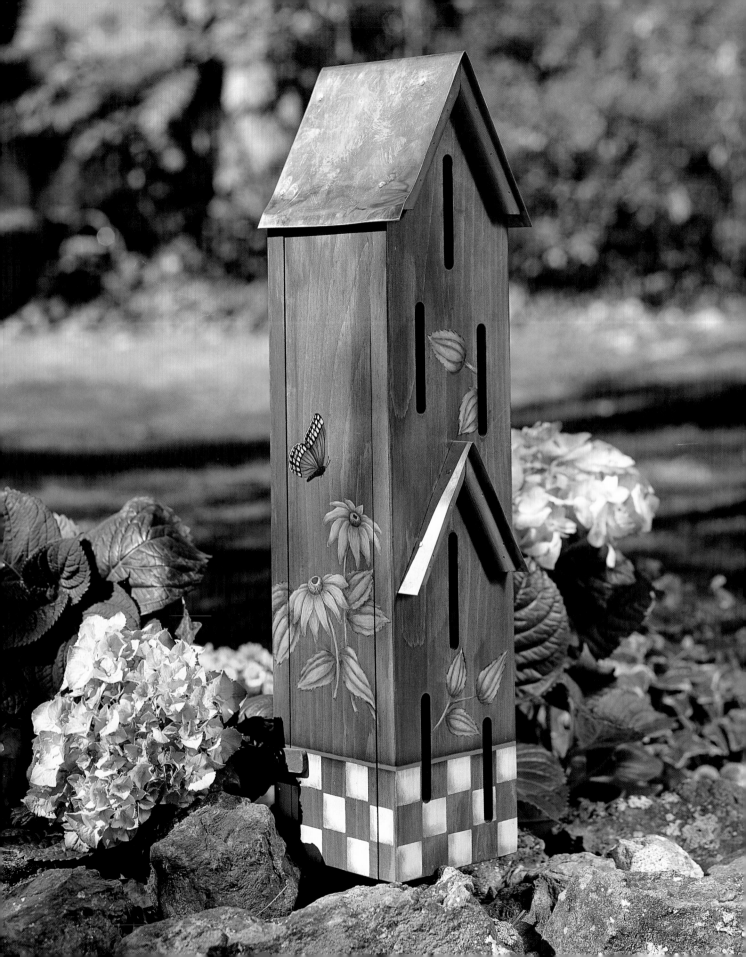

Decorative Painted Projects for the Home

PLAID®

Sterling Publishing Co., Inc. New York
A Sterling / Chapelle Book

Chapelle, Ltd.:
- Owner: Jo Packham
- Editor: Ray Cornia
- Staff: Areta Bingham, Kass Burchett, Jill Dahlberg, Marilyn Goff, Holly Hollingsworth, Susan Jorgensen, Barbara Milburn, Linda Orton, Karmen Quinney, Cindy Stoeckl, Kim Taylor, Sara Toliver, Desirée Wybrow

Plaid Enterprises:
- Editor: Mickey Baskett
- Staff: Sylvia Carroll, Jeff Herr, Laney McClure, Dianne Miller, Jerry Mucklow, Phyllis Mueller

If you have any questions or comments, please contact:
Chapelle, Ltd., Inc., P.O. Box 9252, Ogden, UT 84409
(801) 621-2777 • (801) 621-2788 Fax • E-mail: chapelle@chapelleltd.com
Website: www.chapelleltd.com

Library of Congress Cataloging-in-Publication Data

10 9 8 7 6 5 4 3 2 1

Published by Sterling Publishing Company, Inc.
387 Park Avenue South, New York, NY 10016
©2002 by Plaid
Distributed in Canada by Sterling Publishing
c/o Canadian Manda Group, One Atlantic Avenue, Suite 105
Toronto, Ontario, Canada M6K 3E7
Distributed in Great Britain and Europe by Cassell PLC
Wellington House, 125 Strand, London WCR2 0BB, England
Distributed in Australia by Capricorn Link (Australia) Pty. Ltd.
P.O. Box 704, Windsor, NSW 2756, Australia
Printed and Bound in China
All Rights Reserved

Sterling ISBN 0-8069-6657-2

Table of Contents

Introduction

This book includes over 30 projects to add beauty to your home and bring a smile to anyone receiving them as gifts. From designed mirrors, tables and chairs, decorative glasses, and platters to lamps and vases these easy-to-do projects will add a special touch to indoor or outdoor settings.

Painting and decorating furniture and accessories is satisfying to a creative soul. However, in our busy lives, not many of us think we have time for painting or creating pretty things for ourselves or our friends. Designers of arts-and-crafts products, however, have taken note of how busy our lives have become and are creating tools and art products to make crafting quicker and easier than ever.

With the aid of step-by-step instructions for each project, as well as patterns and clear color photographs, you can create a special piece for your home in an afternoon. You may also learn some new and intriguing painting and decorating techniques. No matter what your skill level, you can create works of beauty and whimsy to bring pleasure for years to come.

Surface Preparation

SURFACE PREPARATION SUPPLIES

Primers to Use

Acrylic-based gesso gives an opaque surface preparation to prime surfaces such as vinyl or canvas. It is brushed, rolled, or sponged on. Gesso can be used to base-coat surfaces that are not white so that the surface color of the project, such as papîer-maché, will not interfere with the brightness of the base-coat color. When applied with a coarse brush or palette knife, gesso can also be used to create texture on a smooth porous surface.

Primer for nonporous surfaces gives surfaces such as glass, sealed ceramics, or metal a proper tooth for painting. Glass and tile medium can be painted onto glass, tile, and other like surfaces to prepare the surface for decorative painting. Metal surfaces such as raw tin can be sprayed with matte acrylic sealer to prepare them for painting.

Primer for porous surfaces such as wood or slate prepares surfaces that, if left unprimed, would absorb too much paint. It can also be used to coat project surfaces where the surface color would interfere with the brightness of the base-coat color. Primer can be brushed or rolled on.

Other Supplies

Sandpaper, 120-grit, is used to sand the surface of wooden projects before base-coating. Wet/dry sandpaper, 220-grit, is used to sand dry base-coats between applications.

Sponge brushes are used for evenly applying a base-coat on the project surface before decorative painting is applied. Sponge brushes are also good for applying finishing coats.

Stylus is a pencil-like tool used to transfer a traced design onto a prepared surface. A pencil or a ballpoint pen that no longer writes may also be used.

Tack cloth is used for removing sanding dust. Tack the surface after every sanding.

Tracing paper is used for tracing a design or pattern. Choose a tracing paper that is as transparent as possible for carefully tracing designs.

Transfer paper is used to transfer a traced design or pattern to the project surface. Choose transfer paper that has a water-soluble coating in a color that will be visible on the base-coat color of the project surface.

Wood filler is used to fill holes in wood. Apply wood filler with a putty knife. Be certain it is thoroughly dry, then sand to a smooth finish.

FINISHING SUPPLIES

Choose sealers that are nonyellowing and quick-drying. Brush-on sealers are economical, but aerosol sealers are convenient and available in gloss or matte finishes. If project is too shiny after finish coats are dry, buff with a fine-grade steel wool or water-moistened 400-grit sandpaper.

On painted surfaces, spray the dry, completed project with a coat of sealer. Let dry. Spray a second coat and let dry. Sand surface with wet 400-grit sandpaper, or with a fine-grade steel wool. Tack away all dust. If needed, apply a third finish coat or more.

If project is made of new wood and was stained or glazed, the wood is rather porous, requiring more coats than a painted surface.

A piece that will receive a lot of use or will be used outdoors will need more finish coats for protection.

Tack cloth

Acrylic sealers give a durable finish that protects your painting without changing its appearance.

Outdoor varnishes give maximum durability for outdoor projects. They brush on, dry clear, and are available in gloss, satin, and matte finishes.

Artist's varnishes are specially designed for decorative artists. These clear, nonyellowing varnishes brush on in thin, even layers for greater control and elimination of brush strokes, and are available in gloss, satin, or matte finishes.

Spray acrylic sealers protect projects for use indoors. They spray on with no yellowing and are available in a lacquer-like high-gloss finish, a subtle glossy sheen, or a soft matte finish.

8

Preparing Glass:

Wash glass item in hot sudsy water to remove any dirt or oil from the surface. Let dry thoroughly.

Preparing Unfinished Wood

Be certain surface is clean and free from dirt and oil. Sand new wood to remove nicks and smooth rough areas. Use 120-grit sandpaper until surface appears dusty and smooth, then use 220-grit sandpaper to finish. Sand with the grain. To round sharp edges for a worn look, use a coarse-grit sandpaper to knock down sharp corners; finish with a fine-grit.

On some new, unfinished furniture, the factory may have allowed a small amount of glue to seep out from the joints. It is important to remove this dried glue if furniture is to be stained or finished with transparent color, or area will not accept finish. Sand away all glue or scrape glue lightly with a putty knife.

NOTE: The base-coat takes better to raw wood than wood that has been sealed.

Using a tack cloth, tack away dust after sanding. (A damp cloth raises the grain of the wood.) Use a bristle brush, vacuum, or blow on the area to remove dust from crevices and corners. Finish project as desired.

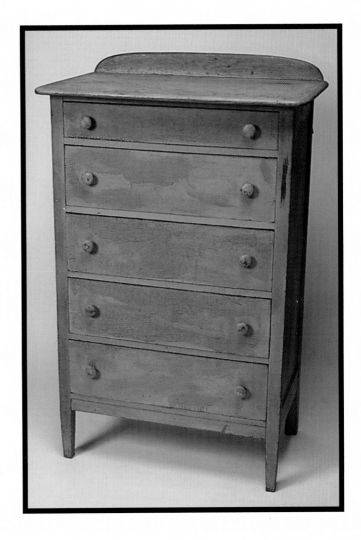

Preparing Old Furniture for Staining

Be certain surface is clean and free from dirt and oil. Using a chemical stripper, strip away old paint or varnish, following manufacturer's instructions. Use a paint scraper to remove paint, varnish, or waste and use newspapers to soak up waste. Work with the grain of the wood.

After most of old finish has been removed, rub surface with coarse steel wool to remove more finish (again, working with grain of wood). Use a ceramic cleaning tool to scrape tight or carved areas. When surface is dry, sand smooth. Using a tack cloth, tack away dust after sanding.

If applying antiquing, glazing, or a color wash, use fine-grit sandpaper or steel wool to prepare the surface. Work in long smooth strokes, because antiquing or color wash will pick up the direction of sanding and will show after it dries.

Tack away dust. (A damp cloth raises the grain of the wood.) Use a bristle brush, vacuum, or blow on the area to remove dust from crevices and corners. Stain the project, following manufacturer's instructions.

Preparing Old Furniture for Painting

Be certain surface is clean and free from dirt and oil. It may not be necessary to completely strip furniture before painting—sand first with a fine-grit sandpaper or steel wool to remove most of the varnish.

If furniture has been painted with oil-based paint or has layers of old paint, it is not necessary to strip piece before applying another layer of paint. Use 120-grit sandpaper until surface appears dusty and smooth, then use 220-grit sandpaper to finish. When sanding an old, painted surface, change sandpaper often due to paint buildup that occurs on paper.

If furniture is going to be painted with a light color over an already dark finish, first apply a coat of white spray primer. The primer seals the wood and prevents any dark areas of wood from showing through a light-colored base coat. It also prevents any knotholes from bleeding through months later. You should not be able to see the dark areas or knotholes after priming. If you do, apply another coat of primer in these areas.

DO NOT USE PRIMER if project is to be stained, glazed, pickled, or given a painted faux finish that involves distressing after painting.

After primer is dry, sand surface with 220-grit sandpaper, working with the grain of the wood. Tack away dust.

Filling Holes

Be certain surface is clean and free from dirt and oil. Fill nail holes, cracks, or gaps where sections of wood meet, with a neutral color of stainable latex filler. Using a small palette knife, apply as little as possible to fill problem area. Remove any excess while wet. Let dry, then sand smooth. If area appears sunken after drying, repeat with a second application to level out. Sand again when dry.

Preparing Vinyl

Be certain surface is clean and free from dirt and oil. Vinyl remnants can be cut to any size. Because painting is done on the back side of the remnant, the top design does not matter. However, make certain to select a vinyl remnant with a smooth design. A rough or textured design will affect the finish on the edges of the finished piece. Sometimes a heavy texture can come through the backing and affect the smoothness of the painting surface.

Cut the vinyl to size and prime the back or bottom side with a bonder/primer or stain-blocking primer.

After the primer has dried, make certain the vinyl piece lies flat. If vinyl curls, take the time to bend the piece until it lies flat. It may be necessary to curl the piece and leave it wrapped with wide rubber bands for a time. Stubborn pieces may even have to be slightly heated with a hair drier or placed over a home furnace vent until slightly softened.

Base-coat the surface with the desired color of acrylic or latex paint, using a low-nap roller.

Steps for Painting Your Project

HOW TO USE THIS BOOK

Read through instructions before beginning a painting project. Paint project steps in the order specified. Keep instructions and project photographs handy while working.

Practice a few strokes before attempting the project. Place tracing paper or plastic over painting worksheet. Practice painting the stroke on the overlay. Practicing strokes will improve your painting.

Project patterns are included in this book. To keep pattern pages intact, photocopy them, enlarging or reducing as necessary to fit your painting surface.

BASIC SURFACE PAINTING

Base coat: Make certain to prepare the project surface with primer or base coat before applying patterns and decorative painting. Primer paint is specially formulated to stick to the wood. Projects painted without primer can peel, crack, or powder off much sooner than those prepared with primer.

When sanding between coats of primer, paint, or varnish, check surface for smoothness. If surface appears to be scratched after sanding, you are either using sandpaper or steel wool that is too coarse, or you are sanding surface before paint, primer, or varnish is completely dry. If this happens, use a finer-grit sandpaper and/or let surface dry and sand again. Using a tack cloth, tack away dust after sanding.

Some projects can be primed or base-coated with antiquing stain instead of paint. Apply antiquing the same way you would paint.

"Sand" with a paper bag: Cut a heavy brown paper bag into 6"-square pieces. When the base coat has dried, rub the surface with the paper bag pieces. The paper polishes the wood fibers and makes the design painting easier. If a second base coat is applied, repeat the paper bag sanding when the second base coat has dried.

Be careful not to use paper bag pieces with printing on them. Most printing inks will rub off onto the painted surface.

Trace and transfer pattern: To trace, place tracing paper over the pattern in the book. Secure with low-tack masking tape. Using a permanent marking pen or pencil, trace major design elements of pattern onto tracing paper. If necessary, enlarge traced pattern on a photocopier to specified percentage. Use the detailed pattern and photographs as visual guides when you paint.

To transfer, position the traced pattern on your project, taping one side with masking tape. Slip the transfer paper, velvet side down, between the tracing and the project surface. Use a stylus to retrace the pattern lines, using enough pressure to transfer the lines but not so much that you indent the surface.

Paint design: Follow the project instructions and painting worksheets for painting the design.

Finish: Most projects are finished with a water-based varnish or acrylic sealer. Apply the finish with a foam or sponge brush after painting is completely dry. Use the largest size sponge brush that can be reasonably used on the project. A large brush requires fewer strokes to cover the project, which in turn means it is easier to apply a smooth finish.

Spray finishes work well with smaller projects and provide an extra-smooth finish. As a rule, a spray finish dries faster than a brush-on finish, but a single coat is not as thick.

Decorative Painting

Nothing complements a piece of furniture more than the custom look of decorative painting, and this book offers something for everyone who wants to try their hand at it. Not only will you find a handy list of supplies and tools, but also patterns and worksheets to help you step by step in your painting. No matter what your skill level, decorative painting is easy with the right tools and supplies.

DECORATIVE PAINTING SUPPLIES

Paints to Use

Acrylic craft paints are a favorite of decorative painters because of their creamy formula and long open time. These premixed, richly pigmented, and water-based paints are available in a huge array of beautiful colors.

Glazes are translucent colors that enhance realistic effects. Neutral glaze can be mixed with other glaze colors and even with paint colors to create tints or more translucent paints. The glazes are perfect for sponging, stippling, and many faux-finishing techniques.

Indoor/outdoor acrylic paints are weather resistant and very durable. They are available in a wide array of colors and provide an opaque finish that does not need to be sealed.

Metallic acrylic craft paints include finishes such as pearl, gemstone, and metallic. They add glimmer, shine, and luster to accent the decorative painting projects.

Painting Mediums to Use

Painting mediums are added to or used along with acrylic colors to change their properties so that they can be used for specific functions such as painting on glass, painting on fabrics, antiquing, etc.

Blending gel makes blending paint colors easier. It keeps the paints moist, giving more time to enhance your artistic expression with shading and highlights. Dampen the area on which you wish to paint with blending gel. As long as the medium stays wet, the paint will blend beautifully.

Extender, when mixed with paint, extends drying time and adds transparency for floating, blending, and washing colors. Create effects from transparent to opaque without reducing color intensity.

Floating medium simplifies one of the most difficult painting techniques. When loaded into the brush along with the paint, the color can literally be "floated" onto the surface. This technique is used for shading and highlighting. It is easier to float a color with the paint plus floating medium than with the paint plus water because you will

have more control, and the floating medium will not run as water will. Simply load brush with floating medium, blot on a paper towel, then load with paint. Floating medium does not contain extenders, so it will not extend the drying time of the paint.

Glazing medium, when mixed with acrylic paint, gives the perfect consistency to a top coat that can be combed or textured with other techniques. It is also used as an antiquing medium. Generally, mix the paint color with glazing medium at a ratio of 2:1.

Thickener, when mixed with paint, creates transparent colors while maintaining a thick flow and consistency. It is also used for marbleizing and other painted faux finishes.

Frosting medium, when painting on glass, gives a nice translucent surface on which to paint.

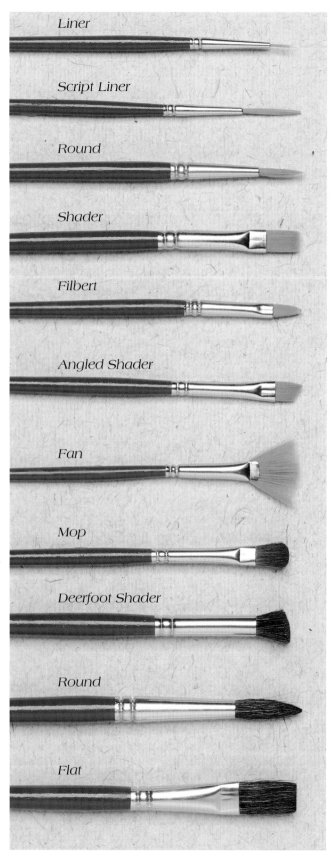

Liner

Script Liner

Round

Shader

Filbert

Angled Shader

Fan

Mop

Deerfoot Shader

Round

Flat

Brushes to Use

The brushes you use are important tools in achieving a successful painted design, so shop for the best you can afford. The size of the brush you will use at any given time depends on the size of the area or design you are painting. Small designs require small brushes, and so forth. Trying to paint without the proper size brush is a major mistake.

Round Brushes

Liner: Liner brushes are round and have shorter bristles than scrollers. These are used to paint small areas. They are often used to paint fine, flowing lines and calligraphic strokes.

Round: Round brushes have a round ferrule and the bristles taper to a fine point at the tip. These brushes are very useful in base-coating, but are also helpful with stroke work. The fine tip works well for painting details and tiny spaces.

Miscellaneous Brushes

Filbert: Filberts are flat brushes with a rounded tip. Because the tips are rounded, they can make very fine chiseled lines. The rounded tips do not leave noticeable start and stop marks. They are also helpful for curved strokes, filling in, and blending.

Filbert Rake: (Not shown) Filbert rake brushes are relatively wide and have sections cut out so the tip resembles a rake. Used for painting grasses or other ragged-edged textures.

Angled Shader: The angled, or angular, shaders are flat brushes with the bristles cut at an angle. The angular brushes paint a fine chiseled edge and are perfect for painting curved strokes, sharp edges, and blending.

Fan: Fan brushes are finishing brushes that are traditionally used clean and dry. Lightly pounce the flat side of the brush on wet surfaces for textured effects. Blend the edges between wet glazes to achieve very soft gradations of color.

Mop: Mop brushes are round brushes with very soft long bristles. They are primarily used for smoothing, softening, and blending edges.

Deerfoot Shader: Deerfoot shaders are round brushes with the bristles cut at an angle. They are used for shading, stippling, and adding texture.

Scroller: Scrollers are long-bristled round brushes used to make fine lines and scrolls. It is helpful for the paint to be thin when using these brushes so it flows easily from the brush onto the project surface.

Dagger: (Not shown) Daggers are long-bristled brushes, cut at a steep angle that resembles a dagger, used for painting lines.

Rectangular Brushes

Scruffy: Scruffy brushes are wide rectangular brushes with short bristles. Scruffy brushes can be purchased or you can simply use a damaged or worn-out brush. They cannot be used for strokes, but work well for pouncing or stippling, dry-brushing, streaking, or dabbing.

Wash/Glaze: Wash/glaze brushes are large flat brushes (sized in inches, e.g. ½", ¾", 1", etc.) for applying washes of color and finishes.

Flat: Flat brushes are rectangular in shape, with long bristles. The chisel edge can make fine lines and the flat edge can make wide strokes. They can carry a large quantity of paint without having to reload often. Flats can be used for double-loading, side-loading, and washing.

Stencil: Stencil brushes are round brushes with either soft or stiff bristles. The paint is applied either with a pouncing motion or a round circular motion. These brushes need very little paint loaded onto them, and excess paint is dabbed off onto a paper towel before applying to the project surface.

Stipple: (Not shown) Stipple brushes can be round or flat. They have stiff, splayed bristles that create irregular patterns when used with a dabbing motion. Specialized stipple brushes can be purchased, but many painters prefer to use old and/or ruined brushes as stipple brushes because of the variety of textures they can produce.

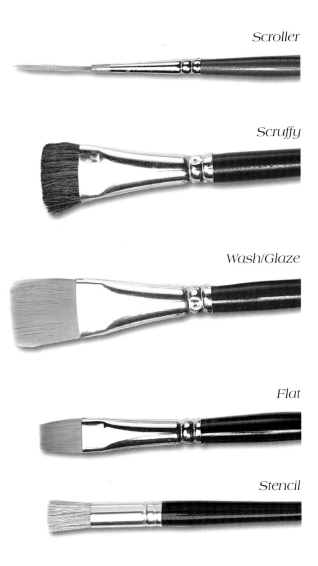

Scroller

Scruffy

Wash/Glaze

Flat

Stencil

Brush Accessories

Water container with clean water is needed for rinsing brushes and to rest brushes on. Keep the ferrule and handle out of the water. A container with a ridged bottom helps clean the bristles.

Brush cleanser is used for cleaning and grooming. Use a liquid brush cleanser that can clean wet or dried paint from bristles and keeps brushes groomed between uses.

Miscellaneous Supplies & Tools

Palette is used for laying out paints. You will load the brush, blend the paint into the brush, and mix colors on a palette.

Palette knife for both mixing and applying paint. Palette knives come in two styles. Both have long flat blades, but one style has an elevated handle to help keep your hand out of the paint. A good palette knife should be thin and flexible when it touches the project surface.

Soft cloth is used for wiping away excess antiquing medium or glaze. It is also used for wiping brushes since rough paper towels can damage bristles.

BRUSH CARE & CLEANUP

Brushes must be properly cleaned and cared for. When you buy a good quality brush, it has sizing in it to hold the bristles in place. Before painting, remove the sizing by gently rolling the bristles between your fingers. Then, thoroughly clean the brush with water. After you have completed the painted design, wash the brush, being careful not to abrade or abuse the bristles. Work the bristles back and forth with a brush cleanser. When you have removed the paint pigment from the brush, leave the cleanser in the bristles and shape them with your fingers. Rinse the brush again before using it to paint.

PAINTING TIPS

Working with Acrylics

• Squeeze paint onto palette, making a puddle of paint about the size of a nickel.

• Pull color with brush from edge of puddle. Do not dip brush in center of puddle, putting too much paint on edges.

• Let each coat dry before applying a second coat. If an area is cool to the touch, it is probably still wet.

• Acrylic paints blend easily. Add white to lighten a color; add black to darken a color.

BASIC PAINTING TERMS

Base-coat—to cover an area with one or several initial coats of paint. Let base coat dry before continuing.

Dirty brush—contains wet color left from the last application. Wipe brush gently, pick up next color, and begin painting. There will be a hint of the previous color along with the new color.

Double-load—loads two paint colors on the brush to make a third color at the center of the brush.

Dry-brush—to apply small amounts of paint to a dry surface. Use a round or filbert brush. Load brush with paint color. Brush several times on a folded paper towel to remove almost all of the paint, then lightly stroke the design.

Float—to shade a color. Load brush with floating medium, then load one corner of brush with a paint color.

Highlight—to lighten and brighten an area. Apply two to three layers of paint color rather than one heavy one. Highlighting on a moist surface has a soft effect; brush on a dry surface for a brighter look.

Inky—is to dilute paint with water until paint is the consistency of ink.

Load—to fill brush with paint color. Stroke brush back and forth in paint until saturated.

Retarder—uses an additive to extend the drying time. Use a small container to hold retarder while painting. Using a flat brush, apply retarder over entire area. It will not hurt the brush to keep it in retarder over extended periods.

Shade—to deepen color within the design and create dimension. Apply paint color with a side-loaded brush on a slightly moistened surface. Shading can be applied as many times as needed to build depth and intensity of color. Let paint dry, then moisten surface again before adding another layer of color.

Side-load—for shading and highlighting. Moisten a flat or filbert brush with floating medium or water. Dip a corner of the brush in paint then stroke brush lightly several times on palette to distribute paint. Turn brush over and stroke opposite side.

Spatter—to speckle a project. Using an old toothbrush, dip bristles into water. Blot on a paper towel to remove excess water. Dip bristles into paint, working paint into bristles by tapping on palette. Aim carefully at project and pull your fingernail across the bristles to release specks of paint.

Stipple—to blend or paint colors with a brush-tip pattern. Pounce tips of brush bristles on project surface. Stipple color with a dry brush technique or blend paint color that has been applied with a side-loaded brush. Wipe with a rag to clean. DO NOT wash brush until you are finished for the day. You cannot stipple with a damp brush.

Tint—to add touches of color for interest and depth. Load a small amount of contrasting paint on a filbert brush and apply to project. To soften color, lightly brush with mop brush to blend out.

Undercoat—to outline, or emphasize, part of the design with white paint when painting on a dark surface, so design paint color shows.

Wash—to alter or enhance a painted design. Apply a layer of transparent color (thinned paint) over a dry base coat.

Wet-into-wet blending—is using two or more colors on the brush and blending while still wet.

How to Load a Flat Brush

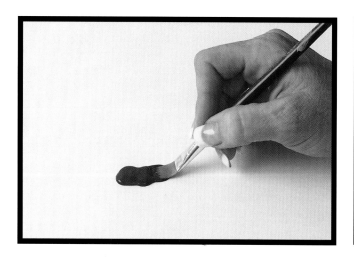

1. Hold brush at edge of puddle of paint color on palette. Pull paint out from edge of puddle with brush, loading one side of brush.

2. Turn brush over and repeat to load other side. Keep flipping brush and brushing back and forth on palette to fully load bristles.

How to Load a Liner

1. Squeeze a puddle of paint color onto palette and dilute it at edge with water.

2. Stroke liner along edge of puddle, pulling paint into bristles. Stroke brush on palette to load paint into bristles.

How to Multiload a Scruffy Brush

1. Hold brush at edge of puddle of first paint color on palette. Push brush straight down into puddle.

3. Look at brush to see that bristles are loaded, half with each color. Do not overblend to mix colors.

2. Turn brush to another area and push into edge of puddle of second color. Turn brush around and pounce onto first color again.

4. Dip brush into puddle of third color.

How to Double-load

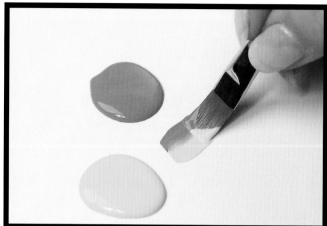

1. Dip flat brush in floating medium. Blot off excess on paper towel until bristles lose their shine. Touch one corner of brush in one paint color. Touch opposite corner of brush in another paint color.

2. Stroke brush to blend colors at center of bristles. Colors should remain unblended on corners.

How to Side-load

1. Load flat brush with extender. Blot off excess. Touch corner of brush in paint.

2. Lift brush and blend on palette. Color will drift softly across bristles, fading into nothing on opposite side.

Basic Brush Strokes

Checkers:
Follow numbers, connecting corners.

Basic Flat Stroke:
Fill in areas or make wide stripes.

Flat Brush

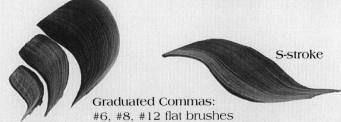

S-stroke

Flat Comma:
Touch flat edge to surface. Pull toward you.

Graduated Commas:
#6, #8, #12 flat brushes

Line:
Using flat brush, paint with chisel edge.

Teardrop Stroke:
Press, turn, and lift.

C-stroke:
Use for rounded edges.

Round Brush

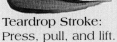

Teardrop Stroke:
Press, pull, and lift.

Violets:
Using all round brushes, make comma strokes.

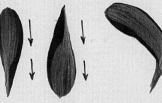

Comma:
Touch edge to surface. Pull toward you.

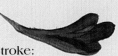

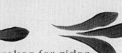

Triple Stroke:
Form teardrop for center and comma strokes for sides.

Liner

Freehand Line

Crosshatching:
Crisscross with thin lines.

Lettering:
Always pull brush toward you.

Hearts:
Using handle end of brush, connect dots and pull down from center.

Dots:
Using handle end of brush, make dots with one load.

Flowers Calico

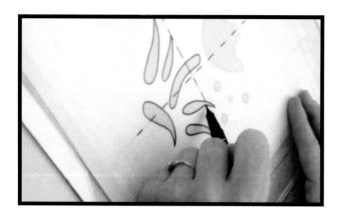

1. Place stencil blank material over desired pattern. Using permanent fine-tip marker, trace design.

Note: A regular ballpoint or felt-tip pen will not write on stencil material.

Tips: A white sheet of paper can be placed under the pattern to make it easier to see. To see even better, place pattern over a light box or tape pattern and stencil material to an outside window.

Use a piece of glass with rounded or taped edges (to avoid cuts) between the pattern and the stencil blank material to make tracing easier and more accurate.

2. Place traced design on piece of glass. Using sharp craft knife, cut out traced areas of design.

Tips: Move the stencil blank material to cut, rather than moving the knife.

Cut small intricate shapes first.

Try to cut each shape without lifting blade from stencil blank material.

Use sufficient pressure to cut through stencil material with one stroke—this prevents making a ragged edge.

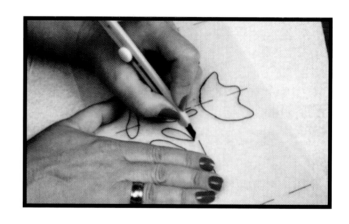

3. *Optional cutting method:* Using electric stencil cutting tool, cut out traced areas of design as explained in Step 2 above.

1. On palette or plastic plate, place and mix adequate amount of acrylic craft paint for stenciling project. Hold stencil brush perpendicular to paint and pull out small amount. Twist brush to concentrate paint in center of brush. Work most of paint to center of brush.

2. Swirl brush on paper towel to remove most of paint.

Note: Stenciling is a dry-brush technique; therefore, most mistakes are made by having too much paint on the brush.

3. Swirl paint onto uncut portion of stencil to determine right amount of paint. Bring paint into cut-out area with either a light pouncing or circular stroke, keeping brush perpendicular to surface. Use more pressure to shade outside edges or to make an opaque print.

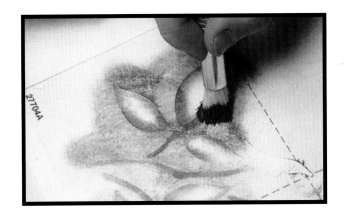

SPECIAL PAINTING TECHNIQUES

Mottled and Splashed:

Base-coat the project as desired. Let dry. Sand lightly and tack away dust.

Brush a generous coat of glazing medium over surface. While wet, mist with vinegar or lemon juice. Immediately add desired glaze color onto the surface by either sponging or stippling with brush.

Optional: Add additional color. If sponging, use large natural sponge dipped in paint and lightly pounce second color onto surface. If spattering, mix paint with alcohol to thin, then spatter mixture onto wet surface.

Note: Metallic paint looks good with this technique.

While surface is still wet, shake alcohol droplets onto the surface. A resist action will immediately occur, resulting in a beautiful surface on which to paint when dry.

Crackled:

If desired, several of the projects in this book can be crackled to give an aged look.

Base-coat project as desired. Let dry. Mix crackle medium plus acrylic paint in equal amounts. Apply generously in areas you wish to crackle. Let dry overnight.

Mix water-based varnish plus acrylic paint in equal amounts and apply as a top coat to the entire project.

Note: Do not brush repeatedly in one place over crackle/paint base-coated areas or crackling may soften. Even if paint does not appear smooth, leave it alone. Once dry, you can lightly brush another layer of top-coat mixture over surface for a more even appearance.

Tips on Crackling:

• Do not dry the paint with a hair dryer when crackling.

• A heavy top coat of paint produces larger cracks. A thin top coat of paint produces smaller cracks.

• A small amount of water added to top-coat mixture gives a fine web of crackling.

• Practice on a test surface before working on your project.

• The weather (humidity or lack of it) may change the results slightly. Low humidity seems to enhance crackling.

Antiquing:

To make a piece look like the color has unevenly darkened with age, antiquing can be done.

Choose color of paint for antiquing. Most often a Burnt Umber or Raw Umber is used. However, any color can be used.

In a small disposable container, add glazing medium. Mix in a little paint.

On a scrap piece of material, or on an unseen surface, test to see if intensity of the antiquing color is appropriate. Add more paint or more glaze to achieve desired effect.

Using a sponge brush or an old rag, wipe the antiquing mixture over painted design.

Using a clean cloth, immediately wipe off any excess antiquing mixture and smooth the painted surface. Let dry thoroughly, then varnish.

Antiquing can be reapplied in areas if desired. Usually, corners, recessed edges, and trim areas are made darker. Flat areas, easily polished and touched, are naturally lighter.

This technique is optional on many of the projects in this book.

Distressing:

Charm can be added by making projects look like they have had long and loving use.

Slightly sand the finished painted surface with medium- to fine-grit sandpaper (150-grit to 220-grit). Do this in the base-coated areas rather than the design areas. Sand in areas that would normally get use, such as corners, edges, or areas near knobs and handles. Remove a little of the paint so some of the raw wood shows through.

Seal or varnish projects after distressing. This will help prevent excess wear on the artfully distressed surfaces.

Combining Distressing and Antiquing:

The two previously described techniques can be combined for yet another effect.

After distressing, antique the project, using a mixture of glazing medium plus Burnt Umber. The brown color will stain raw wood areas that were uncovered with sanding. Let dry thoroughly, then varnish.

Projects

Modern Classics Clock

Pictured on page 28

Designed by
Ginger Edwards

GATHER THESE SUPPLIES

Project Surface:
Wooden clock, approx. 10½"
 tall x 6" wide x 4" deep

Acrylic Craft Paints:
Basil Green
Burnt Sienna
Burnt Umber
Butter Pecan
Clay Bisque
Dark Plum
Emerald Isle
Gray Green
Gray Plum
Italian Sage
Lemonade
Mushroom
Payne's Gray
Pure Black
Raspberry Wine
Sunflower
Titanium White
Warm White

Brushes:
Flats: #4, #6, #10, #12, #14
Liner: #1
Stencil: ⅜"
Wash: 1"

Other Supplies:
Clockworks for 2½" dia. hole
Glazing medium
Ocean sponge
Sandpaper, 220-grit
Screwdriver
Stencil: Moroccan Border
Transfer tools
Water-based varnish, satin

INSTRUCTIONS

Prepare:
1. Using screwdriver, remove clock top. Refer to Surface Preparation on pages 6–10. Prepare clock.

2. Using wash brush, base-coat front panel of clock with Clay Bisque. Base-coat rest of clock with Butter Pecan. Let dry. Apply second coat if necessary. Lightly sand between coats.

3. Refer to Decorative Painting on pages 12–21. Using dampened sponge, texture front panel with a mixture of Butter Pecan plus glazing medium at a ratio of 1:2. Let dry.

4. Refer to How to Stencil on page 23. Using the Moroccan Border stencil and stencil brush, stencil motifs on clock sides with Mushroom.

5. Refer to How to Paint Your Project on page 11. Transfer Modern Classics Pattern on page 27 onto clock.

Paint the Design:
Base-coat:
1. Refer to Bird Worksheet on page 32 as a guide. Using flat brushes, base-coat leaves, stems, and rose hips with a wash of Gray Green plus a small amount of Italian Sage.

2. Using wet-into-wet blending, base-coat shaded areas of petals with Mushroom and highlighted areas with Clay Bisque.

Note: Work with only one or two petals at a time.

3. Base-coat rose center with Sunflower until opaque.

Roses:
1. Shade petals with Mushroom plus a small amount of Dark Plum. Deepen shading with Payne's Gray plus a small amount of Emerald Isle and Burnt Umber.

2. Shade rose centers with Burnt Sienna. Deepen shading with Burnt Sienna plus a small amount of Burnt Umber.

3. Add tints to roses with Dark Plum and Gray Plum.

4. Highlight petals with Warm White plus a small amount of Titanium White, and Titanium White plus a tiny amount of Lemonade.

5. Highlight rose centers with Lemonade.

6. Add stamen around rose centers with Burnt Umber plus a small amount of Pure Black. Add splotches among stamen. Let dry.

7. Add splotches in shaded areas with Dark Plum plus Gray Plum. Add splotches with Sunflower plus a small amount of Lemonade.

Leaves & Rose Hips:

1. Shade leaves, stems, and rose hips with Emerald Isle plus a small amount of Burnt Umber. Deepen shading with Emerald Isle plus a tiny amount of Payne's Gray.

Note: Lower leaves are left with only transparent washes of color.

2. Add tints to leaves, stems, and rose hips with Burnt Sienna plus a tiny amount of Raspberry Wine, or Burnt Sienna plus small amount of Burnt Umber.

3. Highlight leaves, stems, and rose hips with Basil Green plus Lemonade plus Warm White.

4. Using liner, add center veins on leaves with Basil Green/ Lemonade highlight mixture. Add side veins with Emerald Isle/Burnt Umber shading mixture.

5. Add thorns on stems with thinned mixture of Burnt Sienna plus small a amount of Raspberry Wine.

6. Add stamen to some rose hips with thinned mixture of Burnt Sienna plus Burnt Umber. Add splotches among stamen.

Finish:

1. Using wash brush, apply two coats varnish. Let dry.

2. Install clockworks.

3. Replace top.

Modern Classics Pattern

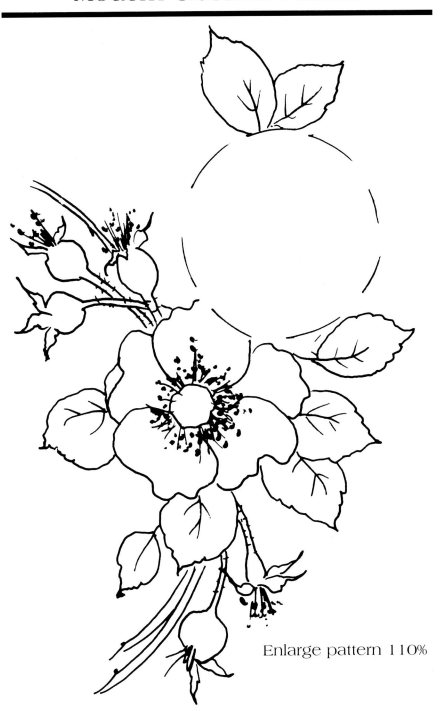

Enlarge pattern 110%

Modern Classics Clock

Instructions begin
on page 26

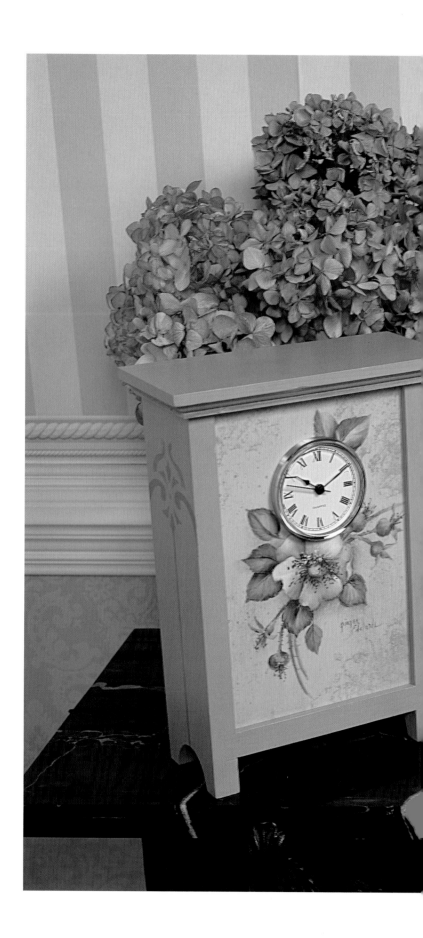

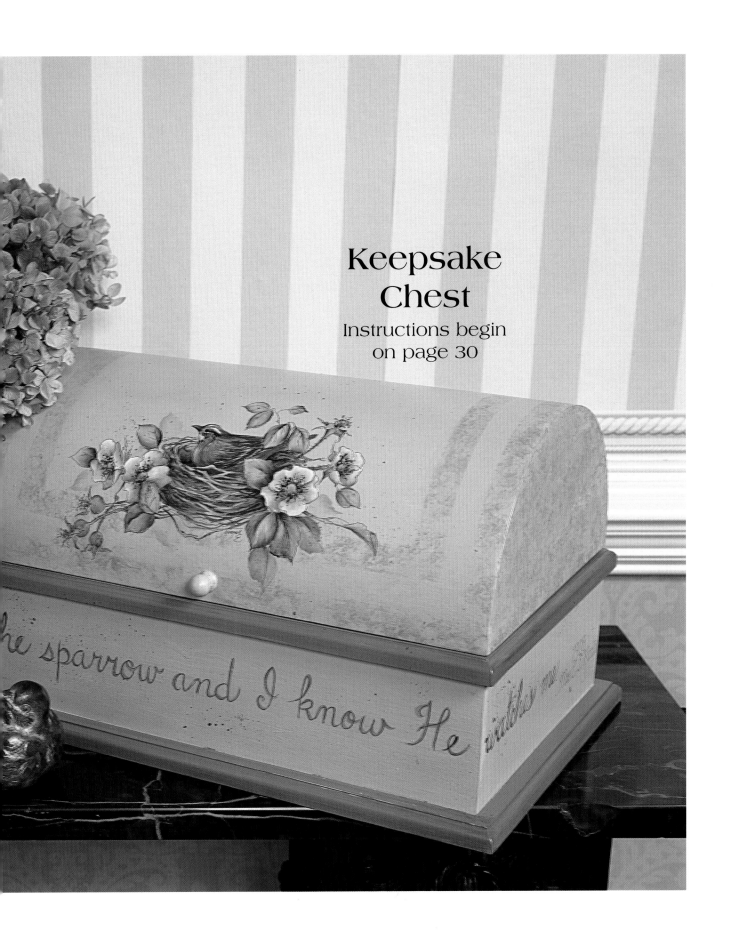

Keepsake
Chest
Instructions begin
on page 30

Keepsake Chest

Pictured on pages 28–29

Designed by
Ginger Edwards

GATHER THESE SUPPLIES

Project Surface:
Round-topped wooden chest,
approx. 9" tall x 13" wide x
8" deep

Acrylic Craft Paints:
Basil Green
Burnt Sienna
Burnt Umber
Butter Pecan
Clay Bisque
Dark Plum
Emerald Isle
Gray Green
Gray Plum
Italian Sage
Lemonade
Mushroom
Payne's Gray
Pure Black
Raspberry Wine
Raw Sienna
Sunflower
Titanium White
Warm White
Yellow Ochre

Brushes:
Filbert rake: ¼"
Flats: #4, #6, #10, #12, #14
Liner: #1
Old toothbrush
Stencil: ⅜"
Wash: 1"

Glazes:
New Gold Leaf

Other Supplies:
Eraser
Glazing medium
Low-tack masking tape,
 ½" wide
Ocean sponge
Pencil
Permanent extrafine-tip
 marker, brown
Ruler
Sandpaper, 220-grit
Spray acrylic sealer, matte
Transfer tools
Water-based varnish, satin

INSTRUCTIONS

Prepare:
1. Refer to Surface Preparation
on pages 6–10. Prepare chest.

2. Using wash brush, base-
coat outside of chest with Clay
Bisque. Apply second coat if
necessary. Let dry. Lightly
sand between coats.

3. Base-coat inside of chest
and trim with Mushroom.

4. Refer to photograph on
pages 28–29 as a guide. Using
pencil and ruler, measure and
mark stripes around lid edge.

*Tip: Make stripes the width of
the masking tape. Position tape
so areas not to be painted will
be protected.*

5. Refer to Decorative Painting
on pages 12–21. Using damp-
ened sponge, texture stripes
and lid side panels with a
mixture of Butter Pecan plus
glazing medium at a ratio of
1:1, plus a small amount of
Mushroom.

*Note: Sponging should be
subtle.*

6. Reserve remaining paint
mixture. Remove tape and
let dry.

7. Texture inside of chest with
reserved paint mixture.

8. Lightly texture inside of
chest with New Gold Leaf
glaze plus glazing medium.

9. Using wash brush, stroke
small amounts of glaze mix-
ture on outside trim of chest.

10. Refer to How to Paint Your
Project on page 11. Using
pencil, transfer Keepsake
Pattern on page 31 onto chest.

Ink the Design:
1. Using marker, trace pattern
lines.

*Tip: Careful attention should be
given when drawing the bird;
other portions of the design
need not be exact. You want
the look of a pen and ink
drawing.*

2. Erase any visible pencil
lines. Lightly spray with acrylic
sealer. Let dry.

Paint the Design:
*Note: The colors are added to
the design in a wash tech-
nique. To make a wash, thin
the paint color with glazing
medium.*

Bird & Nest:
1. Refer to Bird Worksheet on
page 32 as a guide. Using flat
brushes, apply transparent
wash over entire nest area and
bird with Mushroom.

2. Deepen color within nest and begin shading bird with small amounts of Burnt Umber plus Burnt Sienna.

3. Deepen shading on nest and bird with Burnt Umber plus tiny amounts of Payne's Gray.

4. Using liner brush, paint bird's beak and eye with thinned Burnt Umber plus Pure Black. Highlight with Warm White.

5. Using liner brush for smaller areas and filbert rake for larger, add white markings on bird's breast, throat, wing, and side of head with Warm White plus a tiny amount of Butter Pecan.

6. Add markings near bird's eye with tiny amounts of Yellow Ochre plus Warm White.

7. Add detail on side of bird's head with Pure Black.

8. Highlight bird's wings with small amounts of Warm White plus Raw Sienna plus Burnt Sienna.

9. Highlight nest with Warm White plus Raw Sienna plus Burnt Sienna.

Roses & Leaves:
1. Paint roses and leaves, following instructions for Paint the Design: on pages 26–27.

2. Using marker, add detail on roses and leaves.

Note: Lower leaves are left with only transparent washes of color.

Finish:
1. Using liner brush, ink lettering around trunk and add accent lines with thinned Burnt Umber.

2. Using old toothbrush, lightly spatter outside of chest with thinned Burnt Umber.

3. Using wash brush, apply two coats varnish.

Keepsake Pattern

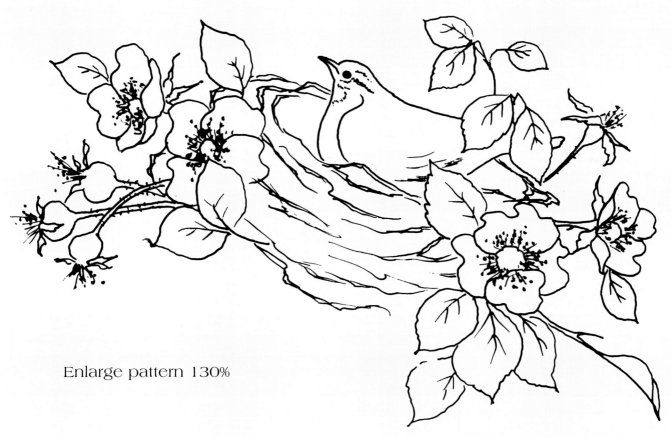

Enlarge pattern 130%

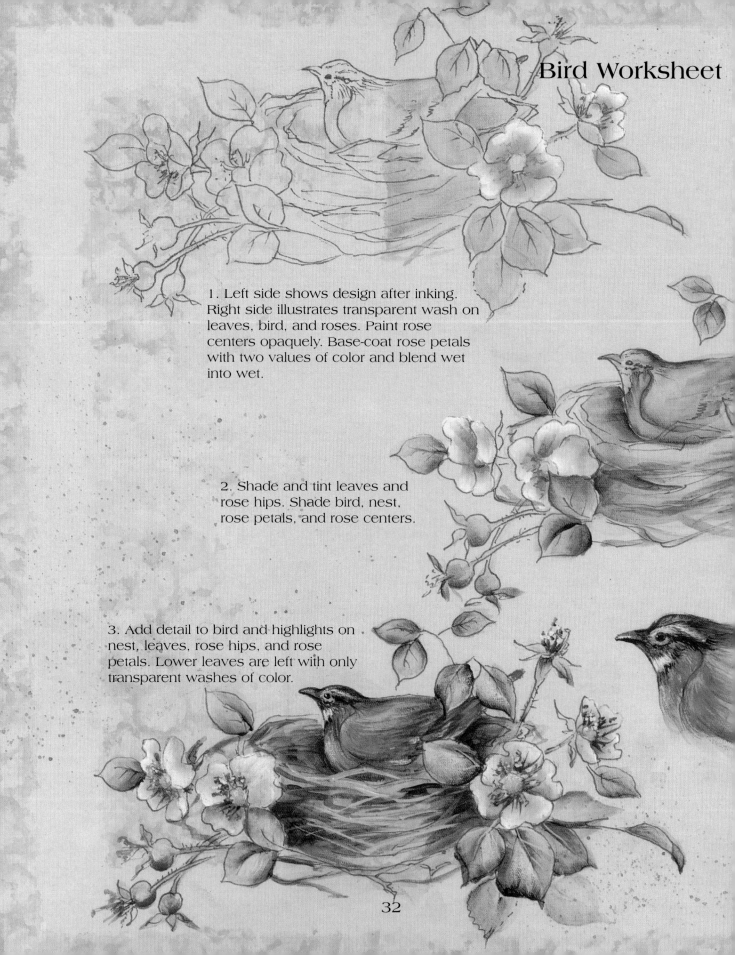

1. Left side shows design after inking. Right side illustrates transparent wash on leaves, bird, and roses. Paint rose centers opaquely. Base-coat rose petals with two values of color and blend wet into wet.

2. Shade and tint leaves and rose hips. Shade bird, nest, rose petals, and rose centers.

3. Add detail to bird and highlights on nest, leaves, rose hips, and rose petals. Lower leaves are left with only transparent washes of color.

Wild Rose & Cherry Worksheet

Wild Rose

1. Using flat brush, base-coat leaves and rose hips with wash. Paint rose centers opaquely. Base-coat petals with two values of color and blend wet into wet.

2. Shade all elements of the design.

A colorful option can be added to floral patterns by including cherries in the design.

Cherry

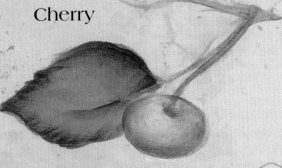

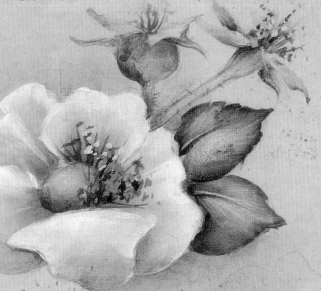

1. Base-coat cherry with two colors and blend wet into wet. Base-coat leaf. Let dry. Shade with brush side-loaded with dark color.

3. Deepen shading by adding tints, highlights, and details. Stamen are added on half the rose for definition.

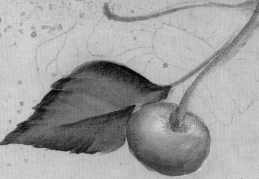

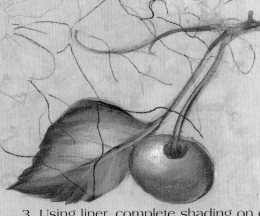

2. Deepen shading on leaf and cherry.

3. Using liner, complete shading on cherry. Add highlights and reflected lights to leaf and cherry. Shade and highlight stem.

Daisy Garland Hurricane

Pictured on page 35

Designed by
Kirsten W. Jones

GATHER THESE SUPPLIES

Project Surface:
Clear glass hurricane lamp
 and base, 8½" tall

Acrylic Craft Paints:
Honeycomb
Sunflower
Thicket
Wicker White

Brushes:
Flat: #10
Liner: #1

Other Supplies:
Frosting medium
Permanent marker, black
Pillar candle, white
Transfer tools

INSTRUCTIONS

Prepare:
1. Refer to Surface Preparation on pages 6–10. Prepare hurricane lamp.

2. Refer to How to Paint Your Project on page 11. Transfer Daisy Garland Pattern below onto hurricane lamp about a third of the way down.

3. Refer to Decorative Painting on pages 12–21. Using flat brush, base-coat design with frosting medium. Base-coat remainder of hurricane below design.

4. Retransfer daisy pattern if necessary.

Paint the Design:
Leaves:
1. Base-coat leaves with Thicket.

2. Highlight leaves with Wicker White.

Daisies:
1. Base-coat daisy petals with Wicker White.

2. Using liner, add detail to petals with Sunflower.

3. Base-coat daisy centers with Sunflower. Shade and add detail with Honeycomb. Let dry.

Finish:
1. Using marker, add outlining, then detail on daisies and leaves.

Daisy Garland Pattern

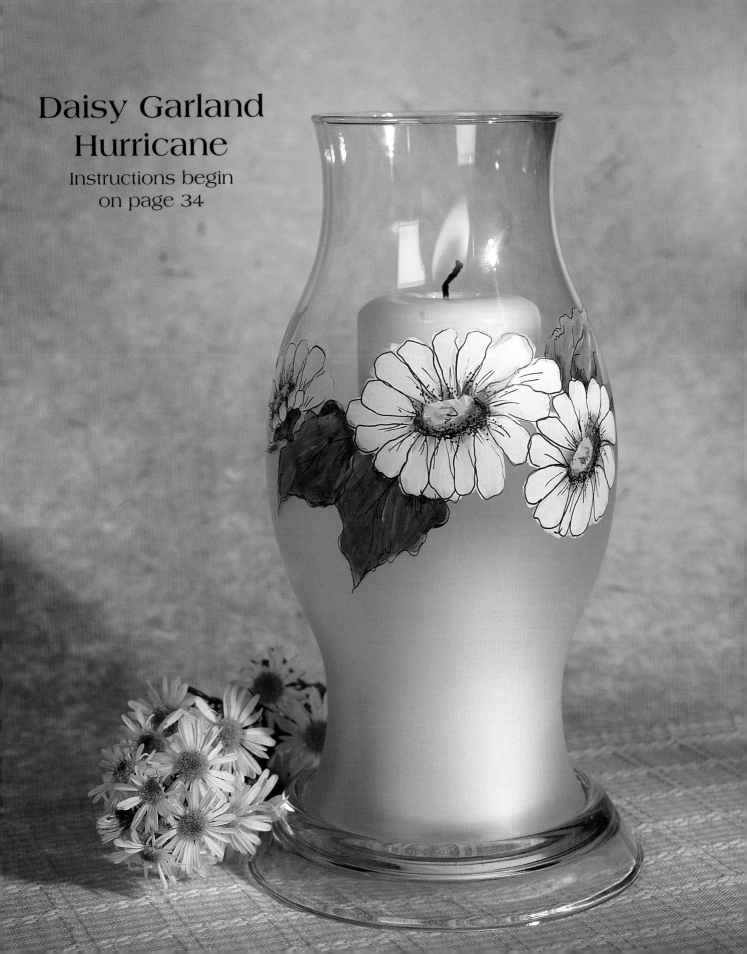

Daisy Garland
Hurricane
Instructions begin
on page 34

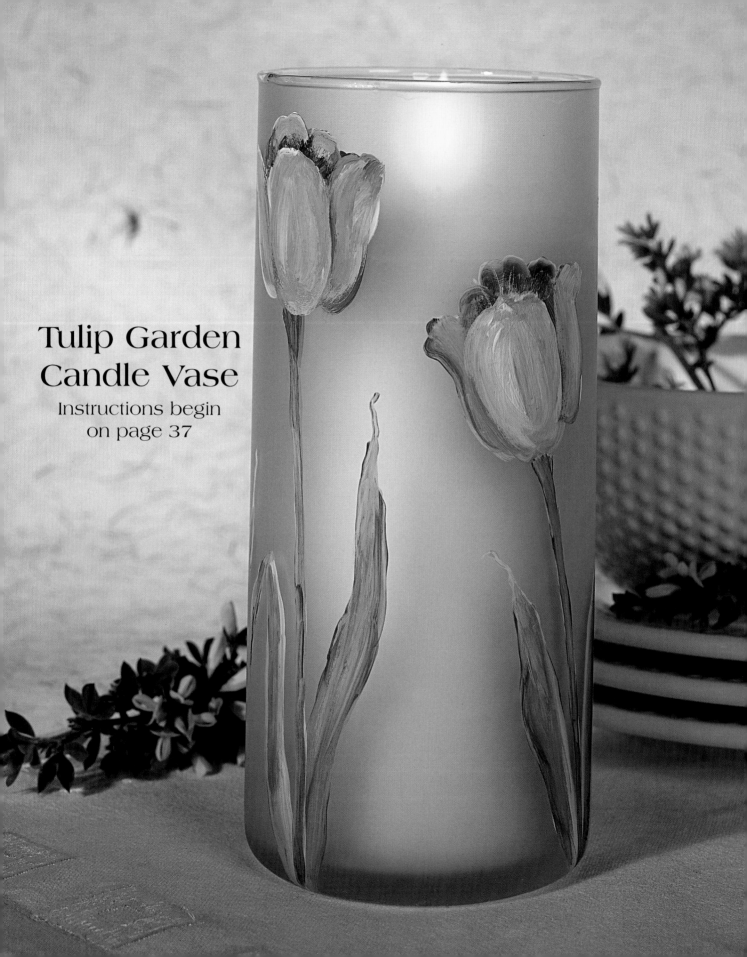

Tulip Garden
Candle Vase

Instructions begin
on page 37

Tulip Garden
Candle Vase

Pictured on page 36

Designed by
Kirsten W. Jones

GATHER THESE SUPPLIES

Project Surface:
Clear glass cylindrical vase,
7⅜" tall x 3¼" dia.

Acrylic Craft Paints:
Burnt Carmine
Fresh Foliage
Old Ivy
Spring Rose
Sunflower
Wicker White

Brushes:
Liner: #1
Round: #5
Wash: 1"

Other Supplies:
Frosting medium
Pillar candle, white
Transfer tools

INSTRUCTIONS

Prepare:
1. Refer to Surface Preparation on pages 6–10. Prepare vase.

2. Refer to Decorative Painting on pages 12–21. Using wash brush, base-coat outside of vase with frosting medium. Let dry.

3. Refer to How to Paint Your Project on page 11. Transfer Tulip Garden Patterns on pages 38–39 onto vase.

Paint the Design:
Leaves:
1. Refer to photograph on page 36 as a guide. Using round brush, base-coat leaves and stems with Old Ivy.

2. Highlight leaves with Fresh Foliage and Wicker White.

Tulips:
1. Base-coat tulips with Spring Rose.

2. Shade petals with Burnt Carmine.

3. Using liner, highlight petals with Spring Rose plus Burnt Carmine. Highlight with Spring Rose plus Wicker White.

4. Add tints to a few petals with Sunflower. Let dry.

Finish:
1. Secure pillar candle inside vase.

Tulip Garden Patterns

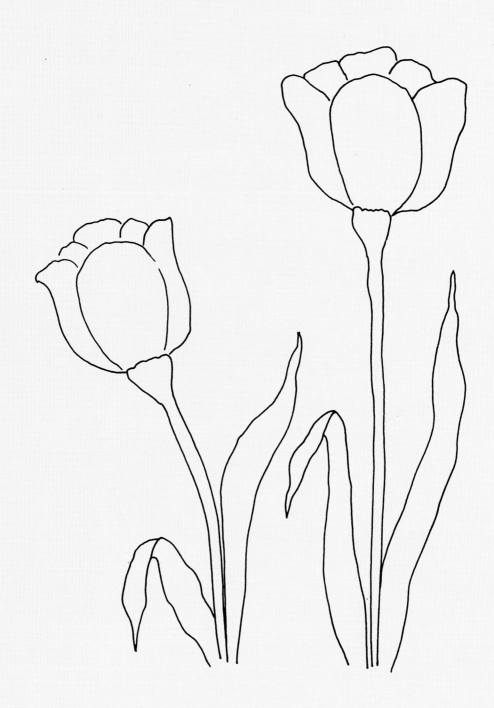

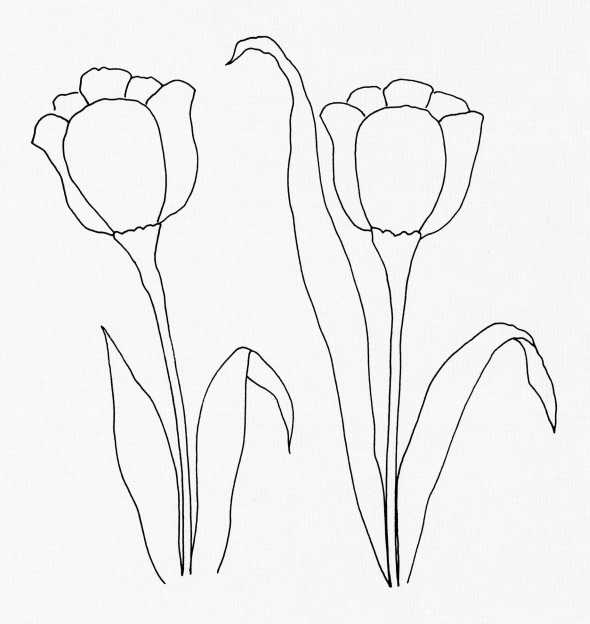

Frosted Violets
Candle Bowl &
Candleholders

Pictured on page 41

Designed by
Peggy Caldwell

GATHER THESE SUPPLIES

Project Surfaces:
Clear glass bowl, approx. 1¾"
 tall x 8" dia.
Clear glass faceted
 candleholders, three
 different styles and heights

Acrylic Craft Paints:
Dioxazine Purple
Hauser Green Medium
Heather
Yellow Ochre

Brushes:
Round: #5
Liner: #00

Other Supplies:
Frosting medium
Permanent marker, brown
Transfer tools

INSTRUCTIONS

Prepare:
1. Refer to Surface Preparation
on pages 6–10. Prepare bowl
and candleholders.

2. Refer to Decorative Painting
on pages 12–21. Using round
brush, base-coat a 1½" rim
around outside of bowl with
frosting medium. Frost sec-
tions of each candleholder.
Let dry.

*Note: Paint only on the outside
of the bowl.*

3. Refer to How to Paint Your
Project on page 11. Transfer
Frosted Violets Pattern below
onto bowl and candleholders.

Paint the Design:
*Tip: Place the four paint colors
and a puddle of frosting med-
ium on palette.*

Violets:
1. Refer to Basic Brush Strokes
on page 21. Using round
brush, paint two petals side by
side for top of violet with
frosting medium plus Heather.

2. Turn project upside down
and paint three petals for bot-
tom of violet, making center
petal slightly longer.

3. Paint side petals.

4. Turn project right side up.
Using liner, add small dots to
center of each violet with
Yellow Ochre.

5. Repeat Steps 1–3 above
with Dioxazine Purple. Repeat
Step 4.

Leaves & Vines:
1. Refer to photograph on
page 41 as a guide. Using
round brush, paint leaves with
frosting medium and Hauser
Green Medium.

2. Using liner, paint vines with
frosting medium plus Hauser
Green Medium.

Finish:
1. Using marker, add detail on
violets, vines, and leaves.

Frosted Violets Pattern

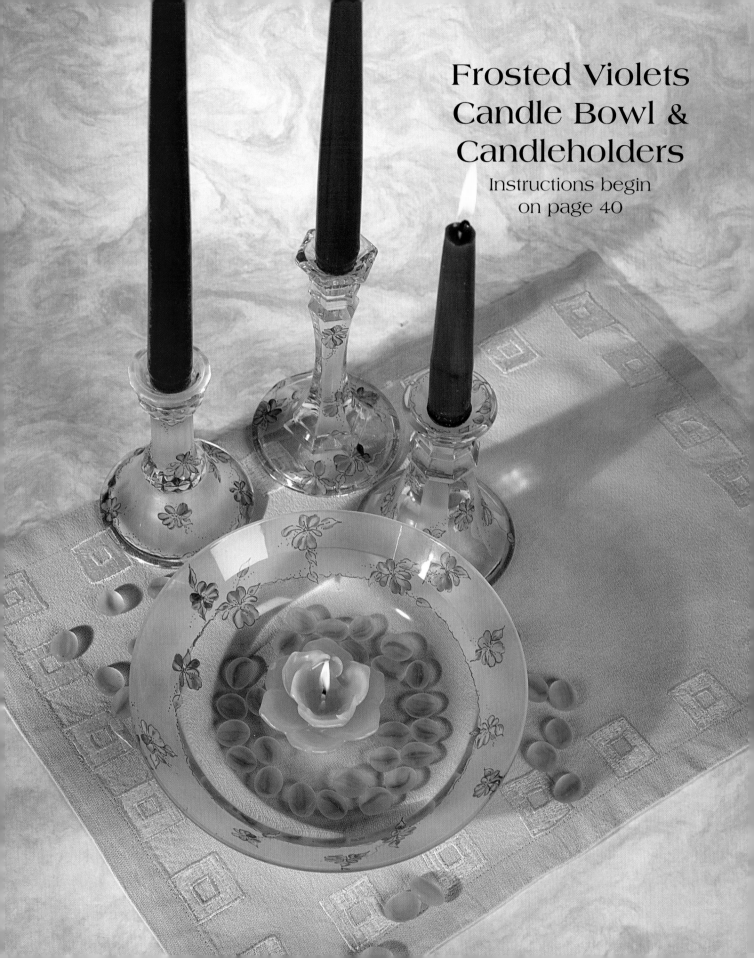

Frosted Violets
Candle Bowl &
Candleholders

Instructions begin
on page 40

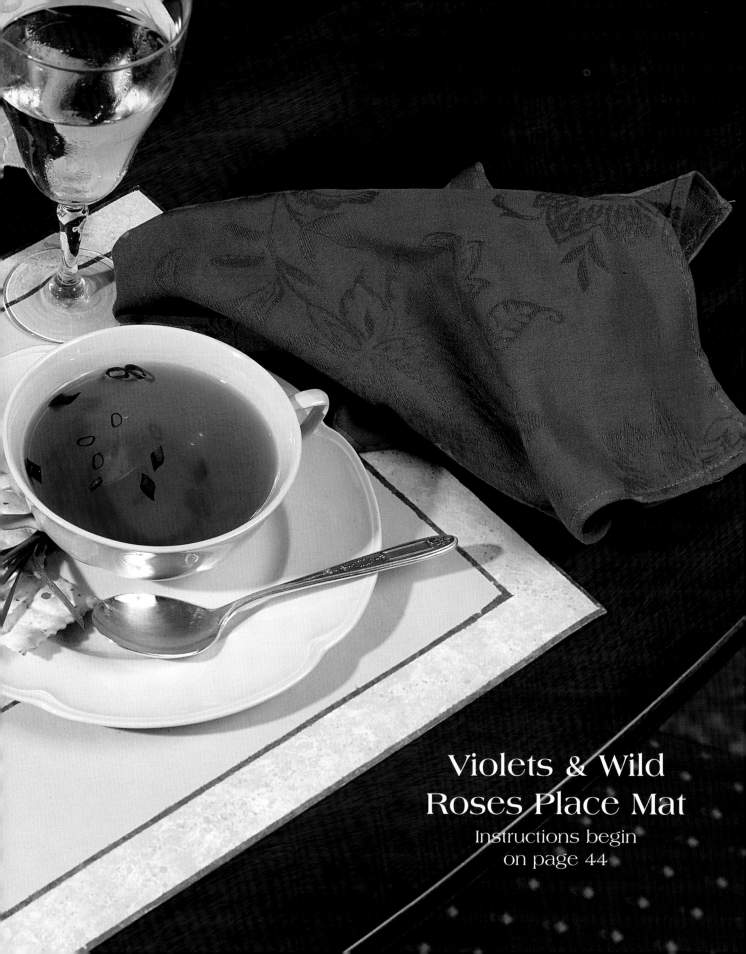

Violets & Wild
Roses Place Mat
Instructions begin
on page 44

Violets & Wild Roses Place Mat

Pictured on pages 42–43

Designed by
Ginger Edwards

GATHER THESE SUPPLIES

Project Surface:
Vinyl floor remnant, 12" x 16"

Acrylic Craft Paints:
Antique Gold (metallic)
Aspen Green
Basil Green
Burnt Sienna
Burnt Umber
Emerald Isle
Lemonade
Light Blue
Linen
Night Sky
Payne's Gray
Periwinkle
Purple
Raspberry Wine
Sunflower
Titanium White
Warm White

Brushes:
Dagger: ¼"
Flats: #4, #8, #10, #12
Filbert rake: ¼"
Liners: #6/0, #10/0
Old toothbrush
Wash: 1"

Other Supplies:
Acrylic sealer, matte
Brown paper bag
Chalk pencil, sharp
Chamois tool
Glazing medium
Low-tack masking tape
Metal primer, gray (or gesso)
Ruler
Striping tape, ⅛" wide
Tack cloth
Transfer tools

INSTRUCTIONS

Prepare:
1. Refer to Surface Preparation on pages 6–10. Prepare vinyl.

2. Using wash brush, paint back side of vinyl with primer for mat. Let dry thoroughly.

3. Using crumpled bag, buff mat. Using tack cloth, tack away particles.

4. Base-coat mat with Light Blue. Let dry.

Texture & Outlines:
Note: Two options are given for this procedure.

Option #1:
1. Using ruler and chalk pencil, measure and mark two lines all around mat: one 1" from edge, another 4" from edge.

2. Position masking tape on lines so 1" border is exposed all around outer edges and center area is also exposed.

3. Refer to Decorative Painting on pages 12–21. Thin Titanium White with glazing medium to a semitransparent consistency. Using dampened chamois tool, texture outer border and center area.

Tip: You may find it helpful to cut strips of paper to lay on the areas that are not protected with tape before you apply the texture.

4. Using old toothbrush, spatter textured areas lightly with Sunflower. Remove tape. Let dry.

5. Refer to photograph on pages 42–43 as a guide. Using dagger brush, paint lines around all sections with Antique Gold. Let dry.

6. Refer to How to Paint Your Project on page 11. Transfer Violets & Wild Roses Pattern on page 45 onto mat.

Option #2:
1. Using #12 flat, paint 5" border all around mat with Antique Gold. Let dry.

2. Apply one coat acrylic sealer. Let dry.

3. Using ruler and chalk pencil, measure and mark two lines all around mat: one 1" from edge, another line 4" from edge.

4. Position striping tape on each marked line. Press tape firmly.

5. Using #12 flat, paint mat with Light Blue, brushing over exposed gold paint and tape. Let dry. Remove tape.

6. Using masking tape, mask off wide border including gold lines.

7. Refer to Option #1: Steps 3–4 above. Texture mat.
Continued on page 46

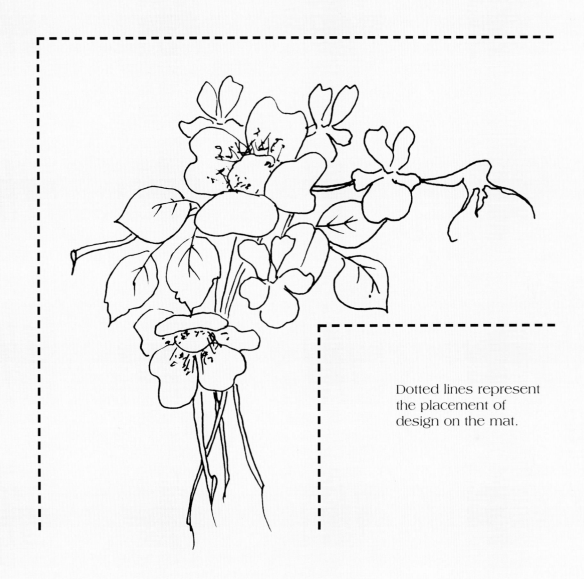

Dotted lines represent
the placement of
design on the mat.

Continued from page 44

Paint the Design:
Roses:

1. Refer to Wild Rose & Cherry Worksheet on page 33 as a guide. Using flat brushes and wet-into-wet blending, base-coat shaded areas of rose petals with Warm White and highlighted areas with Linen..

Notes: Work with only one or two petals at a time.
 Two coats may be necessary to give a smooth, opaque coverage.

2. Base-coat rose center with Sunflower until opaque.

3. Shade petals with Burnt Umber plus a small amount of Emerald Isle. Apply second shading for greater contrast.

4. Add tints on petals with small amounts of Raspberry Wine plus Burnt Umber.

5. Using filbert rake, highlight petals with Titanium White plus a speck of Lemonade.

6. Using #8 flat, base-coat stems with thinned Burnt Umber.

7. Shade stems with Burnt Umber plus a speck of Payne's Gray.

8. Highlight stems with Burnt Sienna plus Warm White.

9. Using #4 flat, shade rose center with Burnt Umber plus Burnt Sienna. Stipple highlights with Sunflower plus Warm White.

10. Using #10/0 liner, add stamen around rose center with Burnt Umber plus a small amount of Payne's Gray. Add splotches among stamen lines with Sunflower.

Leaves & Stems:

1. Using flat brushes, base-coat leaves and stems with Linen.

2. Shade with Aspen Green plus a small amount of Emerald Isle. Deepen shading with Emerald Isle plus a tiny amount of Night Sky.

3. Add tints to some leaves with Raspberry Wine plus a tiny amount of Burnt Umber.

4. Highlight leaves with Lemonade plus Basil Green plus a tiny amount of Titanium White.

5. Using #6/0 liner, add center veins in leaves with highlight mixture.

Violets:

1. Using small flat brushes and wet-into-wet blending, base-coat shaded areas of violet petals with Periwinkle and highlighted areas with Titanium White.

2. Shade petals with small amounts of Purple plus Night Sky. Deepen shading with Night Sky plus a tiny amount of Payne's Gray.

3. Highlight petals with Titanium White plus a speck of Periwinkle.

Tip: A liner brush flattened on the palette as you load it makes a wonderful mini whisk for highlighting.

4. Using #10/0 liner, add small amount of pollen in center of violet with Lemonade plus Titanium White.

5. Add small pistil inside throat with mixture of Raspberry Wine plus Burnt Sienna plus a tiny amount of Sunflower.

Finish:

1. Using wash brush, apply several coats acrylic sealer.

Country
Carrots Plate
Instructions begin
on page 49

Never Enough
Thyme Plate
Instructions begin
on page 50

Country Carrots Plate

Pictured on page 47

Designed by
Nance Kueneman

GATHER THESE SUPPLIES

Project Surface:
White ceramic plate, 10" dia.

Indoor/Outdoor Acrylic Paints:
Black
Cranberry Red
Dandelion Yellow
Mossy Green

Brushes:
Flat: #14
Liner: #1
Rounds: #4, #6

Other Supplies:
Adhesive remover
Glass painting medium
Rubbing alcohol
Transfer tools

INSTRUCTIONS

Notes: Indoor/outdoor acrylic paints can be baked in the oven to make them more permanent. They can be hand-washed, but are not dishwasher safe. Do not allow food to come in contact with the painted surface. If painting a cup or glass, keep paint ¾" away from rim.

Prepare:
1. Refer to Surface Preparation on pages 6–10. Prepare plate. Remove sticky labels and grease from surface with adhesive remover.

2. Wipe surface thoroughly with rubbing alcohol to ensure surface adhesion of paint.

3. Refer to How to Paint Your Project on page 11. Transfer Country Carrots Patterns on page 48 onto plate.

4. Apply glass painting medium to rim of plate.

Paint the Design:
1. Refer to Decorative Painting on pages 12–21. Using #14 flat, evenly space and paint squares around rim with Black. Let dry.

Carrots:
1. Using #6 round, paint carrots with mixture of Dandelion Yellow plus Cranberry Red plus glass painting medium to create carrot color.

2. Paint carrot tops, outlines, and details with Mossy Green plus enough glass painting medium to create transparent dark green.

3. Using #4 round, add dots around carrots with transparent green mixture plus carrot mixture.

4. Using liner, letter "Carrots" at center of plate with Black. Let dry 24 hours.

Finish:
1. Place plate in cold oven. Turn oven to 325° and bake plate for 30–45 minutes.

Tip: Higher temperatures can darken colors.

2. Turn oven off. Let plate cool in oven.

Never Enough Thyme Plate

Pictured on page 47

Designed by
Nance Kueneman

GATHER THESE SUPPLIES

Project Surface:
White ceramic plate, 12" dia.

Indoor/Outdoor Acrylic Paints:
Arbor Green
Bermuda Beach
Black
Coffee Bean
Hot Rod Red
Spring Green
Tangerine

Brushes:
Liner: #2
Rounds: #3, #4

Other Supplies:
Adhesive remover
Rubbing alcohol
Transfer tools

INSTRUCTIONS

Notes: Indoor/outdoor acrylic paints can be baked in the oven to make them more permanent. They can be hand-washed, but are not dish-washer safe. Do not allow food to come in contact with the painted surface. If painting a cup or glass, keep paint ¾" away from rim.

Prepare:
1. Refer to Surface Preparation on pages 6–10. Prepare plate. Remove sticky labels and grease from surface with adhesive remover.

2. Wipe surface thoroughly with rubbing alcohol to ensure surface adhesion of paint.

3. Refer to How to Paint Your Project on page 11. Transfer Never Enough Thyme Patterns on page 51 onto plate.

Paint the Design:
Lettering:
1. Using liner brush, paint lettering with Arbor Green.

Flowerpots:
1. Refer to Decorative Painting on pages 12–21. Using #4 round, paint flowerpots with mixture of Bermuda Beach plus Hot Rod Red plus Tangerine.

2. Refer to photograph below as a guide. Shade and outline flowerpots and paint area below flowerpots with flower-pot mixture plus small amounts of Coffee Bean and Black.

3. Paint leaves in flowerpots with Black plus Spring Green plus Arbor Green.

4. Using #3 round, add some lighter leaves with Spring Green while original leaves are still wet. Let dry 24 hours.

Finish:
1. Place plate in cold oven. Turn oven to 325° and bake plate for 30–45 minutes.

Tip: Higher temperatures can darken colors.

2. Turn oven off. Let plate cool in oven.

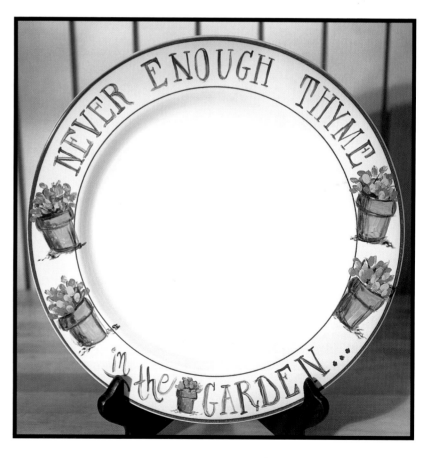

Enlarge
pattern 145%

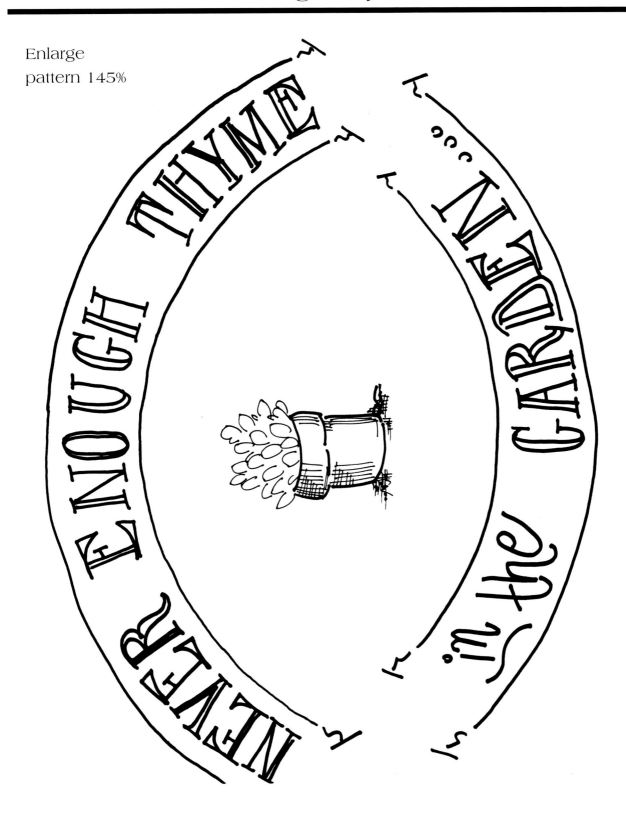

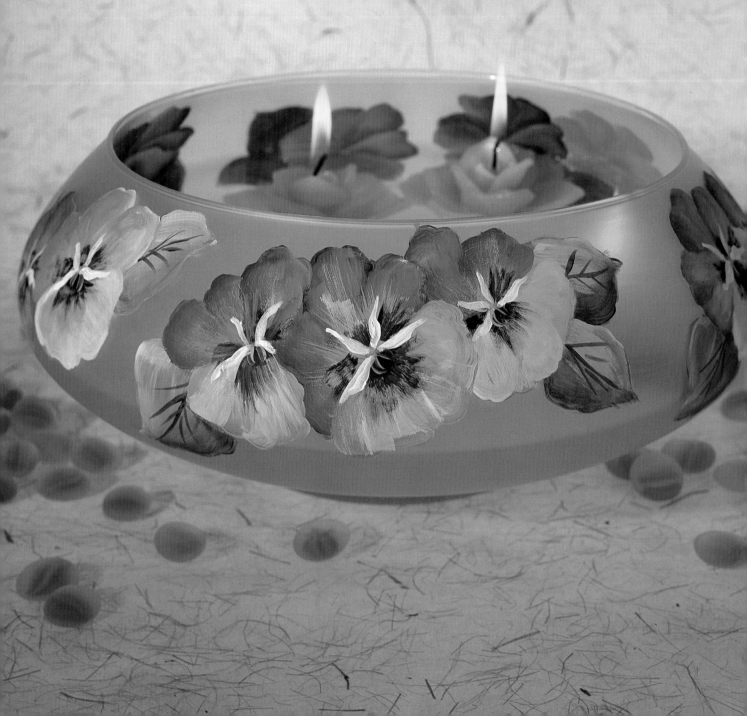

Pansy Bouquet
Candle Bowl
Instructions begin
on page 53

Pansy Bouquet
Candle Bowl

Pictured on page 52

Designed by
Kirsten W. Jones

GATHER THESE SUPPLIES

Project Surface:
Clear glass bowl, 4¼" tall x
 10½" dia.

Acrylic Craft Paints:
Burnt Carmine
Fresh Foliage
Licorice
Light Periwinkle
Olive Green
Thunder Blue
Wicker White
Yellow Light

Brushes:
Flat: #1
Liner: #1
Round: #5

Other Supplies:
Floating candles
Frosting medium
Transfer tools

INSTRUCTIONS

Prepare:
1. Refer to Surface Preparation on pages 6–10. Prepare bowl.

2. Refer to Decorative Painting on pages 12–21. Using flat brush, base-coat outside of bowl with frosting medium. Let dry.

3. Refer to How to Paint Your Project on page 11. Transfer Pansy Bouquet Patterns on page 54 onto bowl.

Paint the Design:
Pansies:
1. Refer to photograph on page 52 as a guide. Using round brush, paint pansy petals.

Note: Vary petal colors, mixing Burnt Carmine, Thunder Blue, Light Periwinkle, and Wicker White to create various shades of blue, burgundy, pink, lavender, or plum.

2. Using liner, shade pansy throats with Licorice. Paint center areas with Wicker White. Add stamens with Olive Green plus Yellow Light.

Leaves:
1. Using flat brush, base-coat leaves with Fresh Foliage.

2. Highlight leaves with Wicker White.

3. Using liner, add veins with Olive Green. Let dry.

Finish:
1. Fill bowl with water to float candles.

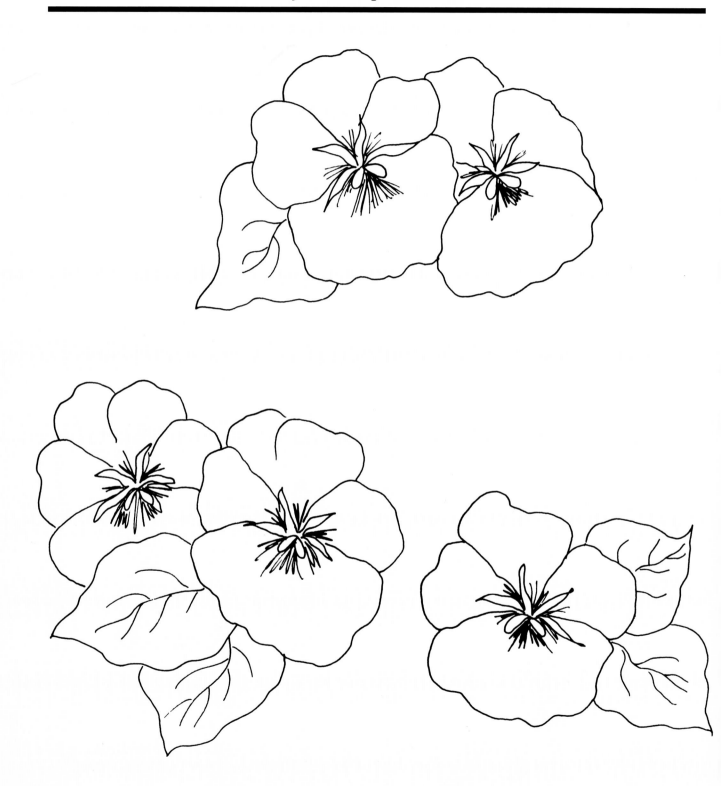

Welcome to
Our Cabin Sign

Instructions begin
on page 56

Welcome to Our Cabin Sign

Pictured on page 55

Designed by
Linda Lover

GATHER THESE SUPPLIES

Project Surface:
Weathered wood, 17" long x
10½" wide x ¾" thick

Indoor/Outdoor Acrylic Paints:
Beachcomber Beige
Cranberry Red
Crown Gold
Dandelion Yellow
Dolphin Grey
Forest Green
Goodnight Blue
Hot Rod Red
Lanier Blue
Lavender
Mocha
Mossy Green
Purple Velvet
Raspberry
Real Blue
Real Red
Spring Green
White

Brushes:
Flats: worn #10
Liner: #1
Shaders: #4, #6, #10
Sponge brush: 1"
Stipple: #6

Other Supplies:
Brass hangers (2)
Chalk
Hammer
Small ocean sponge
Transfer tools

INSTRUCTIONS

Prepare:
1. Refer to Surface Preparation on pages 6–10. Prepare wood.

2. Refer to How to Paint Your Project on page 11. Transfer Welcome to Our Cabin Pattern on page 57 onto wood.

3. Refer to photograph on page 55 as a guide. Using chalk, sketch pattern letters.

Paint the Design:
Background:
1. Refer to Decorative Painting on pages 12–21. Using dampened sponge, texture background foliage with Mossy Green.

2. Using worn flat brush, highlight foliage with Spring Green. Repeat with White. Let dry.

3. Using stipple brush, stipple lilacs behind right side of cabin with Purple Velvet and Lavender.

4. Repeat Step 3 above with Raspberry and White on left side of cabin.

5. Stipple bushes below Raspberry/White lilacs with Dandelion Yellow plus Mossy Green.

Cabin:
1. Using #10 shader double-loaded with Beachcomber Beige and Mocha, paint logs on cabin.

2. Paint cabin door with Mocha.

3. Using #4 shader double-loaded with Mocha and White, paint frame and crossbuck on door. Highlight with White.

4. Using #10 shader double-loaded with Goodnight Blue and Dolphin Grey, paint cabin roof, windows, and porch roof.

5. Using #6 shader double-loaded with Beachcomber Beige and Mocha, paint pillars.

6. Paint line across bottom of cabin with Dolphin Grey. Lightly paint porch with Crown Gold.

Cabin Details:
1. Using #10 shader, paint flowerbox with White.

2. Using liner, add window frame and panes with White.

3. Using stipple brush, stipple foliage in flowerbox with Mossy Green and Spring Green. Stipple vine along pillar and porch roof.

4. Stipple flowers in flowerbox with Real Red and White.

5. Using liner, add hinge and latch on door with Goodnight Blue.

6. Using stipple brush, stipple wreath on door with Crown Gold and Dandelion Yellow.

7. Stipple wreath bow with Forest Green.

8. Using #10 shader, paint chimney with Beachcomber Beige. Shade bricks with Cranberry Red.

Continued on page 58

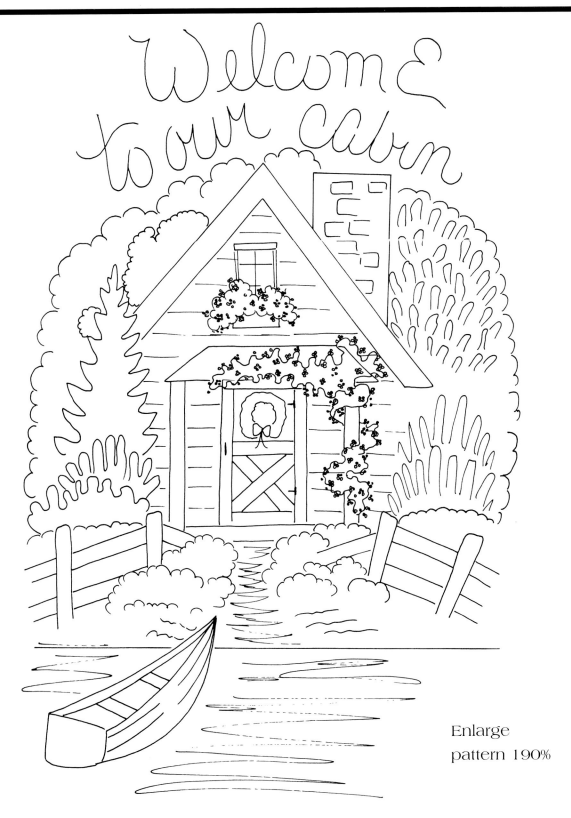

Enlarge
pattern 190%

Continued from page 56

Cabin Surroundings:

1. Using #10 shader, stipple pine tree with Forest Green. Highlight right side with Spring Green.

2. Using liner double-loaded with Mocha and White, paint tree trunk showing through branches.

3. Using worn flat brush, stipple flowers around cabin with the following colors: Hot Rod Red and White, Real Blue and White, Dandelion Yellow and White, Real Red and White.

Note: Use the chisel edge of the brush for some flowers. Add foliage if necessary.

4. Using liner double-loaded with Raspberry and White, dab flowers in vine.

5. Using #10 shader double-loaded with Beachcomber Beige and Mocha, paint path, brushing from left to right.

6. Using stipple brush, stipple grass with Forest Green. Highlight with Spring Green.

Fence:

1. Using #6 shader, paint fence with White and Dolphin Grey. Shade with Mocha.

2. Using stipple brush, stipple base of fence with Dandelion Yellow plus Mossy Green at a ratio of 1:1 and Forest Green. Let dry.

3. Using worn flat brush, stipple flowers around fence with Real Blue and Lanier Blue. Repeat with Raspberry and White.

Water & Boat:

1. Using sponge brush, paint water with Real Blue and White. Avoid painting boat area.

2. Using #10 shader double-loaded with Mocha and White, paint boat.

Finish:

1. Using liner, paint lettering with Beachcomber Beige. Let dry.

2. Using sponge, wipe away chalk lines.

3. Using hammer, attach brass hangers on back of plaque.

There's No Place Like Home Cabinet

Pictured on page 59

Designed by
Susan Fouts-Kline

GATHER THESE SUPPLIES

Project Surfaces:
Baltic plywood, 6" long x 5" wide x ⅛" thick
Wooden cabinet with front-panel insert, approx. 11" tall x 8½" wide x 4" deep

Acrylic Craft Paints:
Barnyard Red
Clay Bisque
Coffee Bean
Country Twill
Dapple Gray
English Mustard
Huckleberry
Indigo
Licorice
Mushroom
Nutmeg
Old Ivy
Raspberry Wine
Skintone
Teal Green
Thunder Blue
Yellow Ochre

Brushes:
Liner: #10/0
Rounds: #2/0, #3
Shaders: #4, #6, #12
Wash: 1"

Continued on page 60

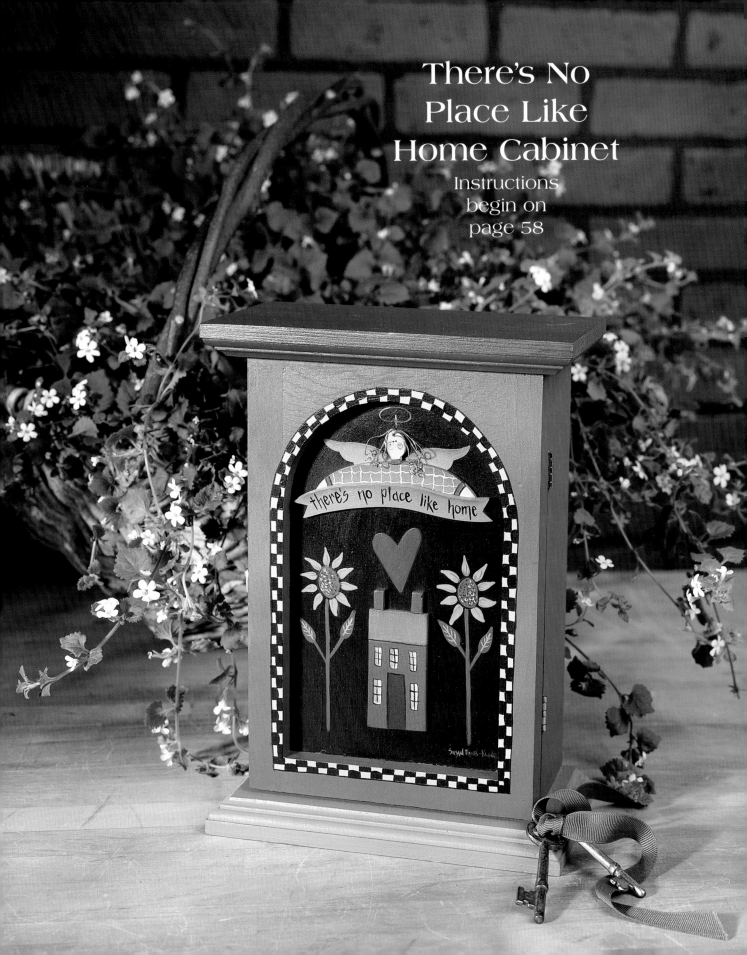

There's No
Place Like
Home Cabinet

Instructions
begin on
page 58

there's no place like home

Continued from page 58

Other Supplies:
Coping Saw
Floating medium
Gold craft wire, 26-gauge
Hand drill with ⅛" bit
Spray acrylic sealer, matte
Transfer tools
White gesso
Wire cutters
Wood glue

INSTRUCTIONS

Prepare:
1. Refer to How to Paint Your Project on page 11. Transfer No Place Like Home Angel, Banner, and House Cutout Patterns on page 61 onto plywood.

2. Using coping saw, cut out patterns.

3. Refer to Surface Preparation on pages 6–10. Prepare cabinet and cutouts.

4. Using #12 shader, base-coat front-panel insert with gesso. Repeat with Licorice.

5. Using wash brush, paint body of cabinet, inside and out, with Thunder Blue.

6. Paint top section of cabinet with Raspberry Wine.

7. Paint bottom section of cabinet with English Mustard.

Paint the Design:
Background:
1. Refer to Decorative Painting on pages 12–21. Transfer Cabinet Design onto cabinet front and insert.

2. Using #12 shader, paint border approximately ½" wide around front-panel insert with Country Twill. Let dry.

3. Retransfer checker pattern if necessary. Paint checkers with Licorice.

Sunflowers:
1. Using #6 shader, base-coat stems and leaves with Old Ivy.

2. Using liner, add veins with Old Ivy plus Clay Bisque at a ratio of 1:3.

3. Using #3 round, base-coat sunflower petals with Yellow Ochre. Add details with Coffee Bean.

4. Base-coat sunflower centers with Coffee Bean. Add details with Licorice.

5. Highlight sunflower centers with Clay Bisque.

Heart:
1. Paint heart between house and banner with Indigo plus Thunder Blue at a ratio of 1:3.

Angel:
1. Using #6 shader, base-coat angel wings with English Mustard.

2. Float along top edge of wings with floating medium plus Coffee Bean.

3. Using #3 round, base-coat angel cutout's face and hands with Skintone. Add swirls on cheeks with Raspberry Wine. Dot eyes with Licorice.

4. Base-coat angel's dress with Teal Green.

5. Using #2/0 round, add plaid lines with Clay Bisque. Add trim on neck and cuffs with Huckleberry.

6. Paint angel's halo with Country Twill.

Banner:
1. Using #6 shader, base-coat banner cutout with Mushroom.

2. Retransfer banner lettering if necessary. Using liner, paint lettering with Licorice.

3. Using #4 shader, float Coffee Bean along top edge of banner with floating medium plus Coffee Bean.

House:
1. Using #12 shader, base-coat house cutout with Huckleberry.

2. Retransfer house pattern if necessary. Paint roof with Dapple Grey.

3. Paint chimneys with Barnyard Red.

4. Paint door with Indigo.

5. Using #4 shader, paint windows with Clay Bisque.

6. Float along edges of house with floating medium plus Coffee Bean.

7. Add details with thinned Licorice.

Finish:
1. Drill ⅛" hole at top of angel's head.

2. Refer to photograph on page 59 as a guide. Using wire cutters, cut craft wire into four 5" lengths and partially thread through hole in angel's head. Bend wires toward face. Cut and curl for hair as desired.

Tip: If the angel's hair is too shiny, paint on a little Nutmeg.

3. Glue angel and banner in place, propping banner against arms with bottom edge resting against cabinet.

4. Glue house in place. Let dry thoroughly.

5. Spray entire cabinet (inside and out) with acrylic sealer.

No Place Like Home Patterns

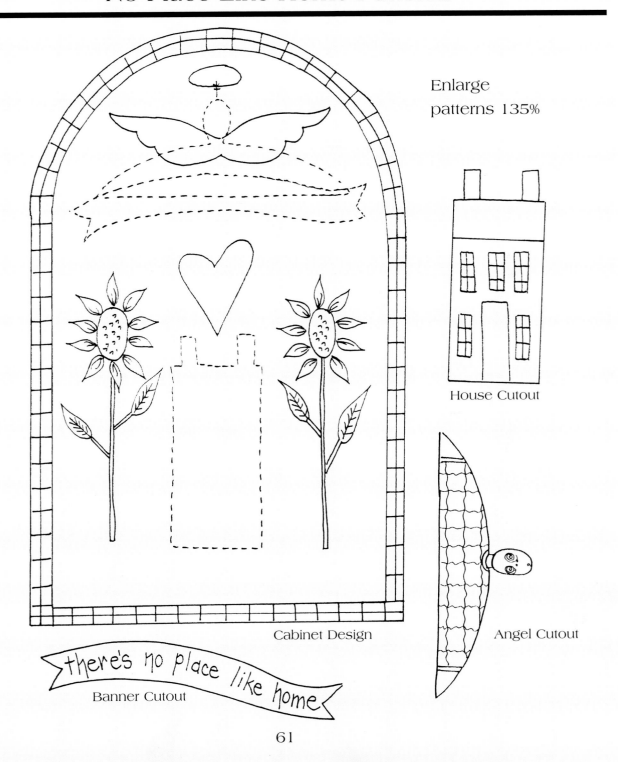

Enlarge
patterns 135%

House Cutout

Cabinet Design

Angel Cutout

Banner Cutout

61

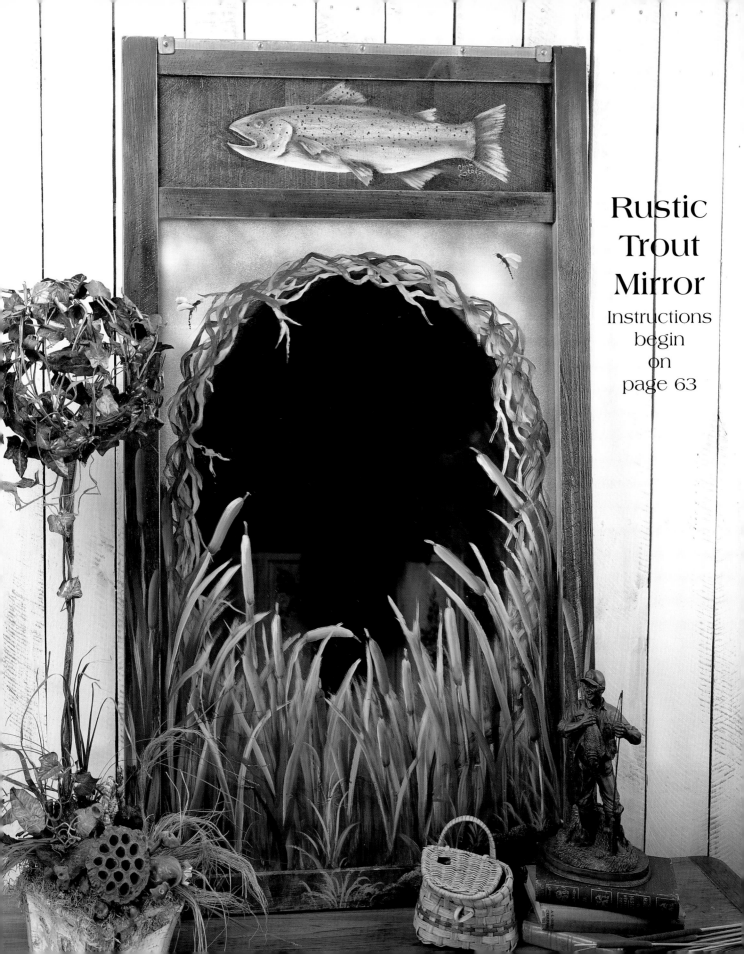

Rustic
Trout
Mirror
Instructions
begin
on
page 63

Rustic Trout Mirror

Pictured on page 62

Designed by
Chris Stokes

GATHER THESE SUPPLIES

Project Surface:
Mirror with finished wooden
 frame, approx. 39" tall x 22"
 wide

Acrylic Craft Paints:
Asphaltum
Basil Green
Burnt Sienna
Burnt Umber
Clover
English Mustard
Licorice
Olive Green
Raspberry Wine
Sunflower

Brushes:
Filbert: ½"
Flat: #12
Liner: #1
Round: #5
Sponge brush: 2"

Other Supplies:
Low-tack masking tape
Sandpaper, 220-grit
Scissors
Scrap of paper to mask mirror
Spray acrylic sealer, matte
Spray paints: Cornflower Blue;
 Ivory
Transfer tools
Water-based varnish

INSTRUCTIONS

Prepare:
1. Refer to Surface Preparation
on pages 6–10. Prepare mirror.

2. Using scissors, cut large
oval from scrap paper for
center mirror mask. Tape in
place. Mask off frame.

Background:
1. Refer to photograph on
page 62 as a guide. Spray sky
area around oval mask with
Cornflower Blue. Spray clouds
with Ivory. Let dry. Remove
oval mask and set aside. Un-
mask frame.

Paint the Design:
Vine Wreath:
1. Refer to Decorative Painting
on pages 12–21. Using round
brush double-loaded with
Burnt Umber and a touch of
Licorice, paint wiggley line for
background wreath vines.

2. Add center wreath vines
with Asphaltum and Licorice.

3. Add foreground wreath
vines with English Mustard and
Licorice.

Grasses:
1. Using flat brush, paint grass
with mixes of Burnt Umber,
Raspberry Wine, and Olive
Green. Start at bottom of mirror
and pull upwards, flipping
brush at end of stroke.

2. Double-load brush with
Clover and English Mustard.
Add lighter colored grass.

Cattails:
1. Refer to How to Paint Your
Project on page 11. Transfer
Rustic Trout Cattails Patterns
on page 65 onto mirror.

2. Double-load flat brush with
Clover and English Mustard.
Paint cattail stems.

3. Double-load filbert with
Burnt Umber and English
Mustard, then tip in Sunflower.
Paint cattails, pulling from top
to bottom.

4. Add foreground grasses
with Clover. Highlight with
Sunflower. Add some grass
and cattails onto wooden
frame.

Moss-covered Rock:
1. Using round brush, base-
coat rock with Licorice plus a
tiny amount of Burnt Umber.
Let dry.

2. Multiload brush with Basil
Green, Burnt Umber, and
Sunflower. Pounce mixture
on rock.

Dragonflies:
1. Using round brush, paint
dragonfly bodies with Licorice.

2. Double-load brush with
Licorice and Sunflower. Paint
comma stroke for wings.

Trout:
1. Transfer Rustic Trout Pattern
on page 64 onto top of wood-
en frame.

2. Using flat brush, paint top of
fish with Olive Green. Pick up
some Clover as work progress-
es downward.

3. Double-load brush with
Raspberry Wine and Sunflower.
Paint center of fish.

4. Paint bottom of fish with
Clover. Pick up some Basil
Green and Sunflower for belly
area.

Rustic Trout Pattern

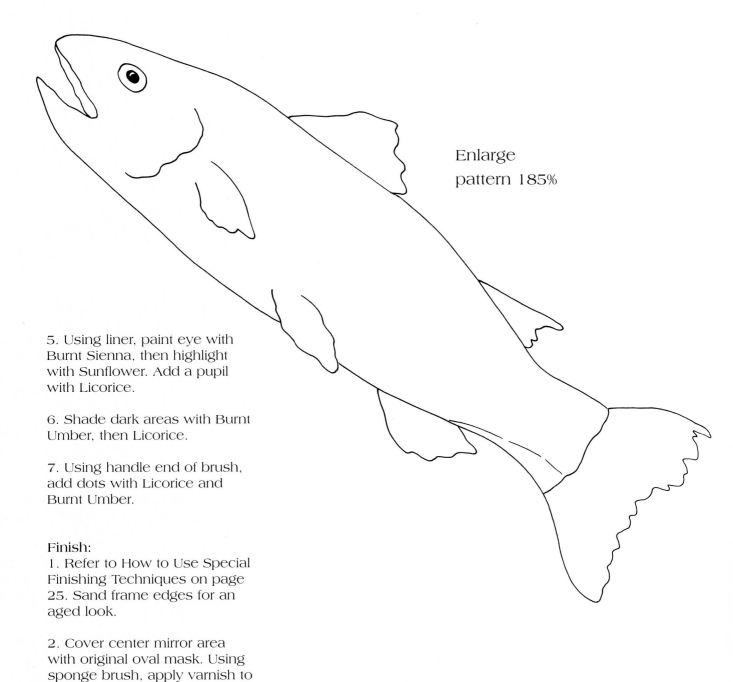

Enlarge
pattern 185%

5. Using liner, paint eye with Burnt Sienna, then highlight with Sunflower. Add a pupil with Licorice.

6. Shade dark areas with Burnt Umber, then Licorice.

7. Using handle end of brush, add dots with Licorice and Burnt Umber.

Finish:
1. Refer to How to Use Special Finishing Techniques on page 25. Sand frame edges for an aged look.

2. Cover center mirror area with original oval mask. Using sponge brush, apply varnish to frame.

3. Spray painted areas with acrylic sealer.

Rustic Trout Cattails Patterns

Enlarge
pattern 185%

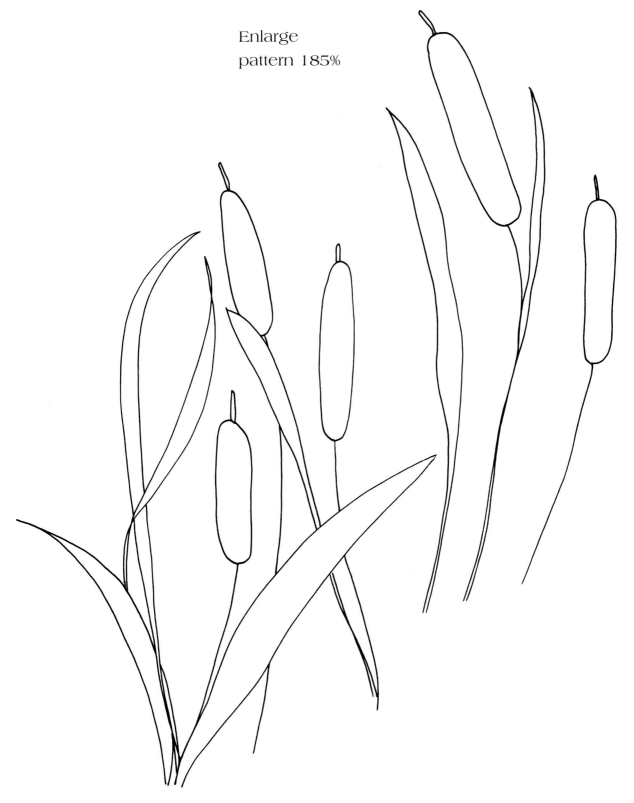

Butterfly Fantasy Vase

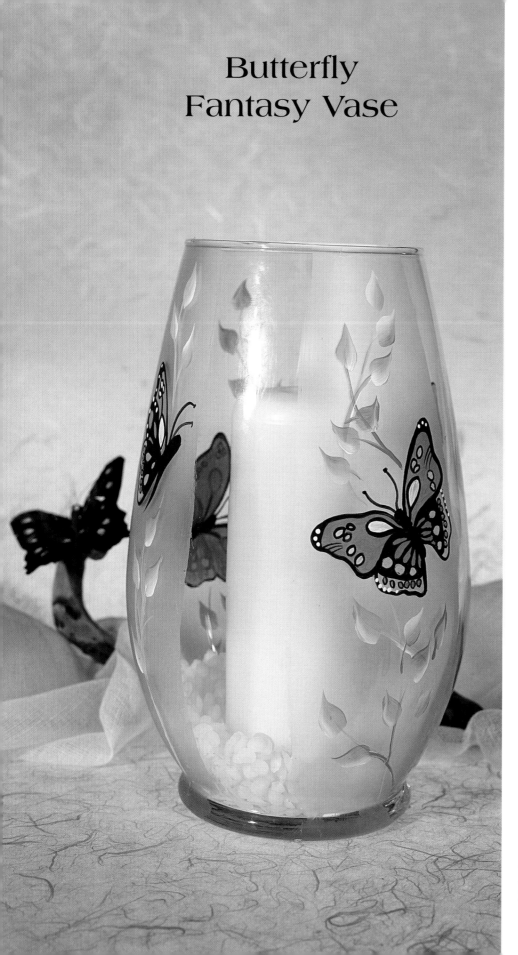

Butterfly Fantasy Vase

Designed by
Marianne Ajamy

GATHER THESE SUPPLIES

Project Surface:
Clear glass candle vase,
 approx. 10" tall

Acrylic Craft Paints:
Aqua
Hauser Green Light
Medium Yellow
Pure Black
Pure Orange
Titanium White

Brushes:
Flat: #6
Script liner: #1

Other Supplies:
Frosting medium
Masking tape, 2" wide
Transfer tools
Stylus

INSTRUCTIONS

Prepare:
1. Refer to Surface Preparation on pages 6–10. Prepare vase.

2. Evenly position four pieces of masking tape vertically on vase from top to bottom.

3. Refer to Decorative Painting on pages 12–21. Using flat brush, base-coat exposed glass with frosting medium, being careful not to cover top and bottom rims. Remove tape. Let dry 24–48 hours.

4. Refer to How to Paint Your Project on page 11. Transfer Butterfly Fantasy Patterns on page 67 onto vase.

Paint the Design:
Butterflies:

1. Refer to photograph on page 66 as a guide. Using flat brush, base-coat top wings of large butterfly with Pure Orange and bottom wings with Medium Yellow.

2. Base-coat top wings of small butterfly with Aqua and bottom wings with Medium Yellow.

3. Retransfer butterfly pattern if necessary. Using script liner, add markings on both butterflies. Let dry, then add Pure Black areas and outlines.

4. Using a stylus, add dots with Titanium White.

Branches:

1. Double-load flat brush with Hauser Green Light and Titanium White. Paint stems with chisel edge.

2. Paint leaves.

Butterfly Fantasy Patterns

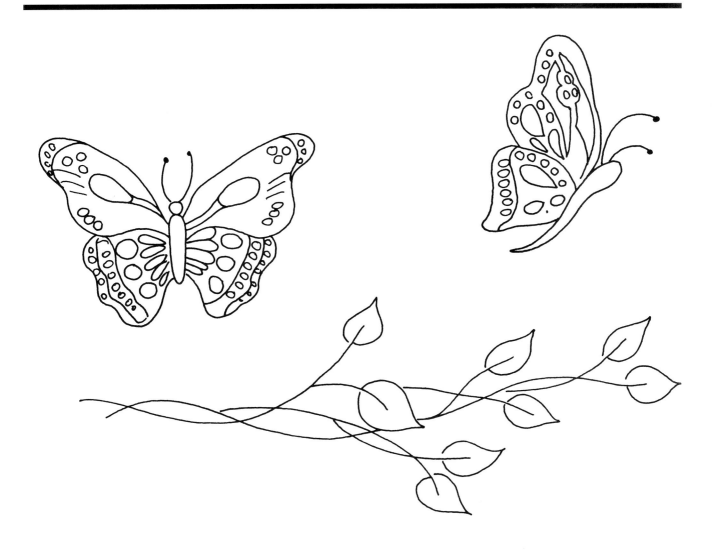

Nasturtiums Outdoor Thermometer

Pictured on page 69

Designed by
Pat Wakefield

GATHER THESE SUPPLIES

Project Surface:
Slate, 10" square

Indoor/Outdoor Acrylic Paints:
Barn Red
Bright Yellow
Leaf Green
Salem Green
White

Acrylic Craft Paints:
Medium Yellow
Pure Orange
Red Light

Brushes:
Flats: #3, #10
Liner: #1
Round: #3
Sponge brush: 2"

Other Supplies:
Glue suitable for outdoor use
Outdoor sealer, satin
Outdoor thermometer
Scrap of slate or stiff brush
Soft brush
Transfer tools

INSTRUCTIONS

Prepare:
1. Place craft slate flat on a table. Using scrap of slate or stiff brush, with a back and forth motion, scrape off loose or chipped particles.

2. Using soft brush, rinse with water.

3. Refer to How to Paint Your Project on page 11. Transfer Nasturtiums Pattern on page 70 onto slate.

Paint the Design:
Note: The colors are blended very little in this project. Apply a thick amount of paint following the direction of the curve of the petal, leaf, or stem. Let paint dry some on the palette before painting and it will be a thicker consistency.

Base-coat:
1. Refer to Decorative Painting on pages 12–21. Using #10 flat and round brush, base-coat all areas of design with white.

Leaves & Stems:
1. Base-coat leaves and stems with Leaf Green.

2. Using round brush, shade leaves and stems with Salem Green. Deepen shading with a second coat.

3. Highlight leaves and stems with Bright Yellow plus White plus Medium Yellow.

4. Paint medium value on some leaves with Leaf Green plus Pure Orange.

5. Using liner, add veins with White plus Medium Yellow.

6. Refer to photograph on page 69 as a guide. Add White outline on some edges.

Nasturtiums:
1. Using #10 flat, base-coat petals with Bright Yellow.

2. Using #3 flat, shade petals with Pure Orange, Red Light, and Barn Red.

3. Highlight petals with Medium Yellow plus White.

4. Add White outline on some edges.

5. Undercoat blossom extension with Bright Yellow plus Pure Orange. Highlight with White.

6. Paint blossom center with Barn Red.

7. Using liner, add lines and dots with White and Barn Red.

Finish:
1. Using sponge brush, apply several coats outdoor sealer. Let dry.

2. Glue thermometer to slate.

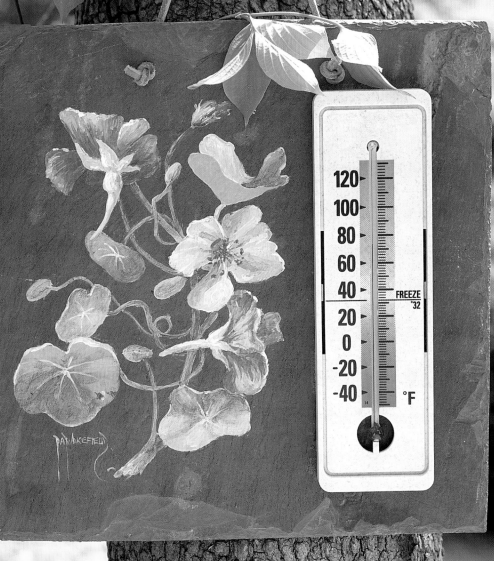

Nasturtiums
Outdoor
Thermometer

Instructions
begin on
page 68

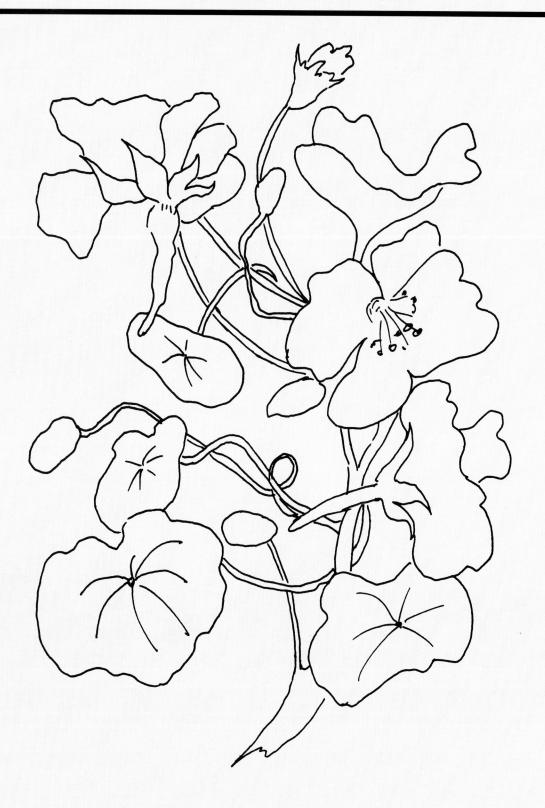

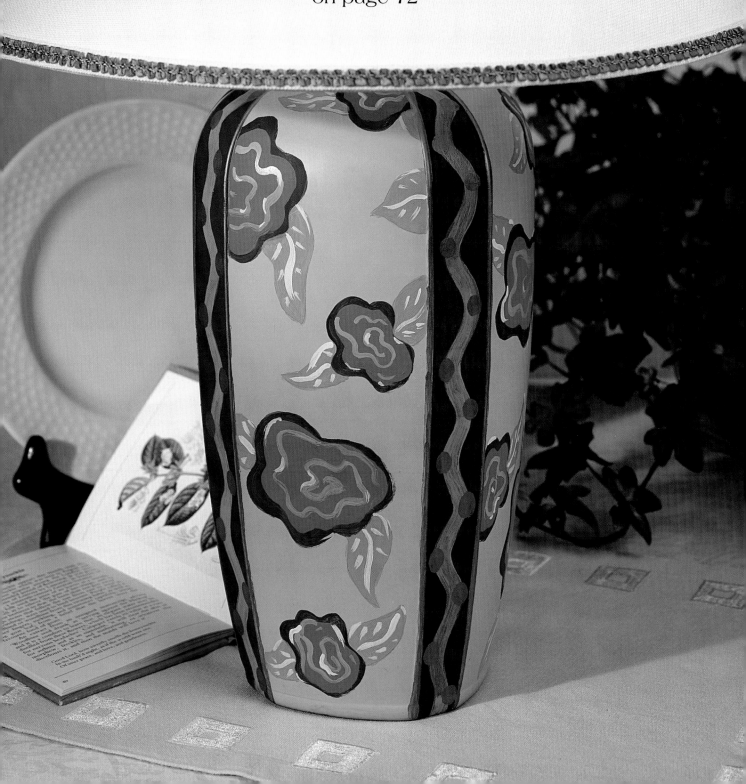

Modern Roses
Lamp
Instructions begin
on page 72

Modern Roses Lamp

Pictured on page 71

Designed by
Laney C. McClure

GATHER THESE SUPPLIES

Project Surface:
Pink ceramic ginger jar lamp,
12"-tall base

Acrylic Craft Paints:
Antique Gold (metallic)
Bayberry
Heather
Purple Passion
Wicker White

Brushes:
Flat: #12
Script liner: #1
Sponge brush: 1"

Other Supplies:
Frosting medium
Transfer tools

INSTRUCTIONS

Prepare:
1. Refer to Surface Preparation on pages 6–10. Prepare lamp.

2. Refer to Decorative Painting on pages 12–21. Using sponge brush, paint ceramic area with frosting medium. Let dry.

3. Refer to How to Paint Your Project on page 11. Transfer Modern Roses Patterns below onto lamp base and lamp shade.

Paint the Design:
Stripes:
1. Using flat brush, base-coat stripes with Purple Passion.

2. Add a wavy line on each stripe with Bayberry. Let dry.

3. Using script liner, add a large dot along outer edges of wavy lines with Antique Gold.

4. Add a line along outer edges of stripes with Antique Gold.

Roses:
1. Using flat brush, base-coat roses with Purple Passion. Paint half-roses next to stripes. Let dry.

2. Paint center area of roses with Heather, letting Purple Passion show around edges. Let dry.

3. Using script liner, add swirly lines for petals with Wicker White thinned with frosting medium.

4. Randomly accent roses with Wicker White

Leaves:
1. Using flat brush, paint leaves with Bayberry.

2. Using script liner, add veins with Wicker White.

Modern Roses Patterns

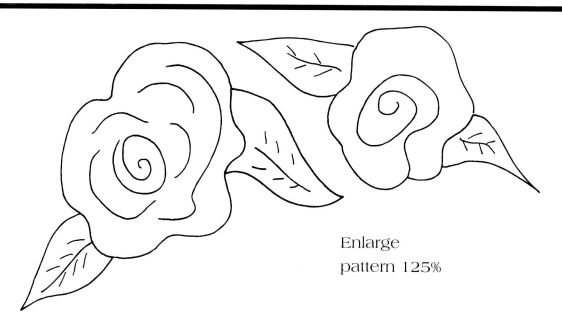

Enlarge
pattern 125%

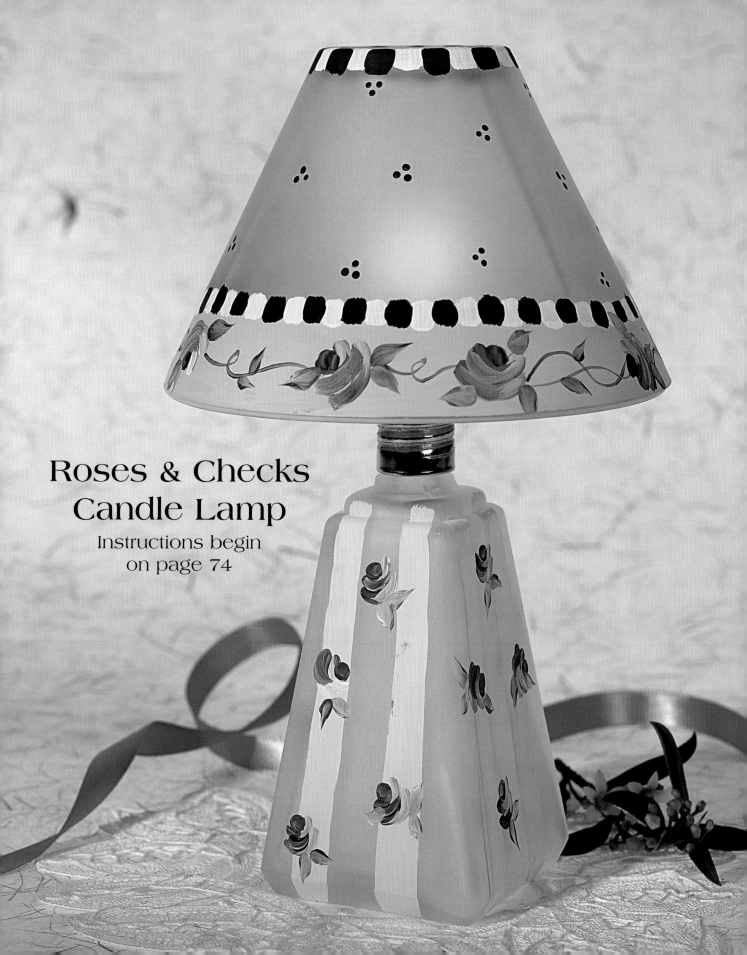

Roses & Checks
Candle Lamp

Instructions begin
on page 74

Roses & Checks Candle Lamp

Pictured on page 73

Designed by
Kirsten W. Jones

GATHER THESE SUPPLIES

Project Surface:
White frosted glass candle
 lamp, 7½" tall x 4" square
 base

Acrylic Craft Paints:
Burnt Carmine
Licorice
Olive Green
Sunflower
Wicker White

Brushes:
Flat: #8
Liner: #1
Round: #6

Other Supplies:
Masking tape: 1" wide
Transfer tools

INSTRUCTIONS

Prepare:
1. Refer to Surface Preparation on pages 6–10. Prepare base.

Paint the Design:
Stripes:
1. Refer to Diagram A below as a guide. Position three pieces of masking tape vertically from top to bottom on one side of lamp base: one in center and one along each side edge. Repeat for remaining sides of base.

2. Using flat brush, paint two stripes on each side of base with Sunflower. Remove tape. Let dry.

3. Paint a 1" border around lower edge of shade with Sunflower. Let dry.

Roses:
1. Refer to How to Paint Your Project on page 11. Transfer Roses and Checks Patterns on page 75 around rim of shade and individual roses randomly onto striped base.

2. Refer to Decorative Painting on pages 12–21. Using flat brush, paint checker border around top edge of shade and along top edge of Sunflower border, alternating Licorice and Wicker White.

3. Using round brush double-loaded with Burnt Carmine and Wicker White, paint roses.

Leaves & Vines:
1. Using round brush double-loaded with Olive Green and Wicker White, paint leaves.

2. Using liner, paint vines on shade with Olive Green.

Details:
1. Using the handle end of brush in an all-over pattern, paint three-dot clusters between checker borders with Burnt Carmine.

Diagram A

Roses & Checks Patterns

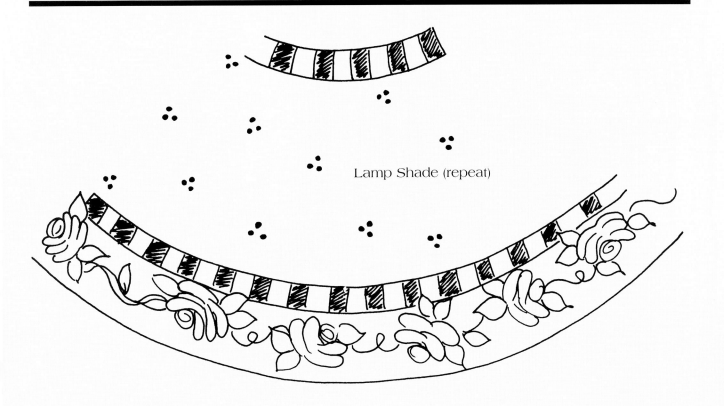

Lamp Shade (repeat)

Lamp Base

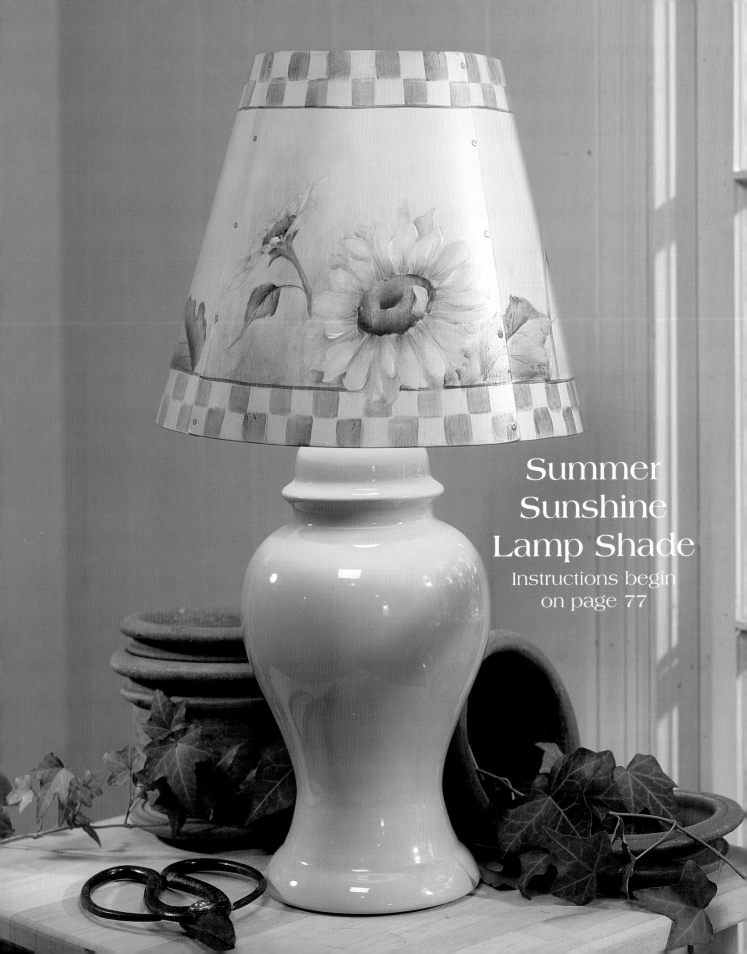

Summer
Sunshine
Lamp Shade
Instructions begin
on page 77

Summer Sunshine Lamp Shade

Pictured on page 76

Designed by
Ginger Edwards

GATHER THESE SUPPLIES

Project Surface:
Unfinished wooden lamp
shade, 8¾" tall x 10" dia.

Acrylic Craft Paints:
Acorn Brown
Autumn Leaves
Ivory White
Lemon Custard
Maple Syrup
Real Brown
Thicket
Thunder Blue
Turner's Yellow
Wicker White

Brushes:
Dagger: ¼"
Flats: #6, #10, #12, #14, #16
Liner: #10/0
Sponge brush: 1"

Other Supplies:
Eraser
Sandpaper, 220-grit
Pencil
Tack cloth
Transfer tools
Water-based varnish
Wood sealer

INSTRUCTIONS

Prepare:
1. Refer to Surface Preparation on pages 6–10. Prepare shade.

2. Using sponge brush, apply base-coat over outside of shade with Ivory White plus wood sealer at a ratio of 1:3.

3. Apply base-coat over inside of shade with Thicket plus wood sealer at a ratio of 1:3. Let dry.

4. Sand outside of shade to smooth surface and to expose the wood grain. Tack away dust.

Paint the Design:
Note: Thin all base-coat paints with water to a transparent consistency.

1. Refer to How to Paint Your Project on page 11. Using pencil, transfer Summer Sunshine Pattern on page 78 onto outside of shade.

Base-coat:
1. Refer to Decorative Painting on pages 12–21. Using #14 flat, base-coat sunflower petals with Lemon Custard plus Turner's Yellow.

2. Using #12 flat, base-coat sunflower centers with Maple Syrup.

3. Using #6 and #10 flats, base-coat leaves, calyxes, and stems with Thicket. Let dry.

Leaves, Calyxes & Stems:
1. Using #16 flat, shade leaves, calyxes, and stems with Thicket plus a small amount of Thunder Blue. Deepen shading with this mixture plus Real Brown.

2. Highlight with Wicker White plus Lemon Custard plus a small amount of Thicket.

3. Tint some edges and make splotches with Maple Syrup and/or Maple Syrup plus a tiny amount of Real Brown.

4. Using liner, add veins with thinned Thicket.

Sunflowers:
1. Using #14 flat, shade petals with Acorn Brown. Deepen shading with Acorn Brown plus a small amount of Real Brown.

2. Add tints to petals near centers and on some edges with Autumn Leaves.

3. Highlight petals with Lemon Custard plus Wicker White.

4. Using #16 flat, shade centers with Real Brown plus Maple Syrup. Deepen shading with this mixture plus a small amount of Thunder Blue.

5. Highlight centers by lightly stippling with Lemon Custard.

Details:
1. Using #14 flat, paint checks with thinned Thicket. Let dry.

2. Using dagger brush, add line along inside edges of borders with Maple Syrup plus Autumn Leaves. Let dry.

3. Using #16 flat, lightly float Thunder Blue behind flowers.

Finish:
1. Erase any visible pencil lines.

2. Using sponge brush, apply two coats varnish.

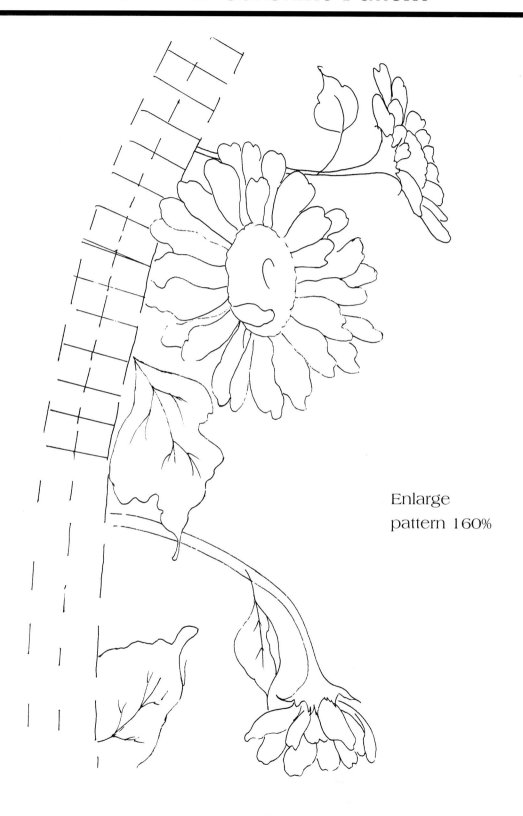

Enlarge
pattern 160%

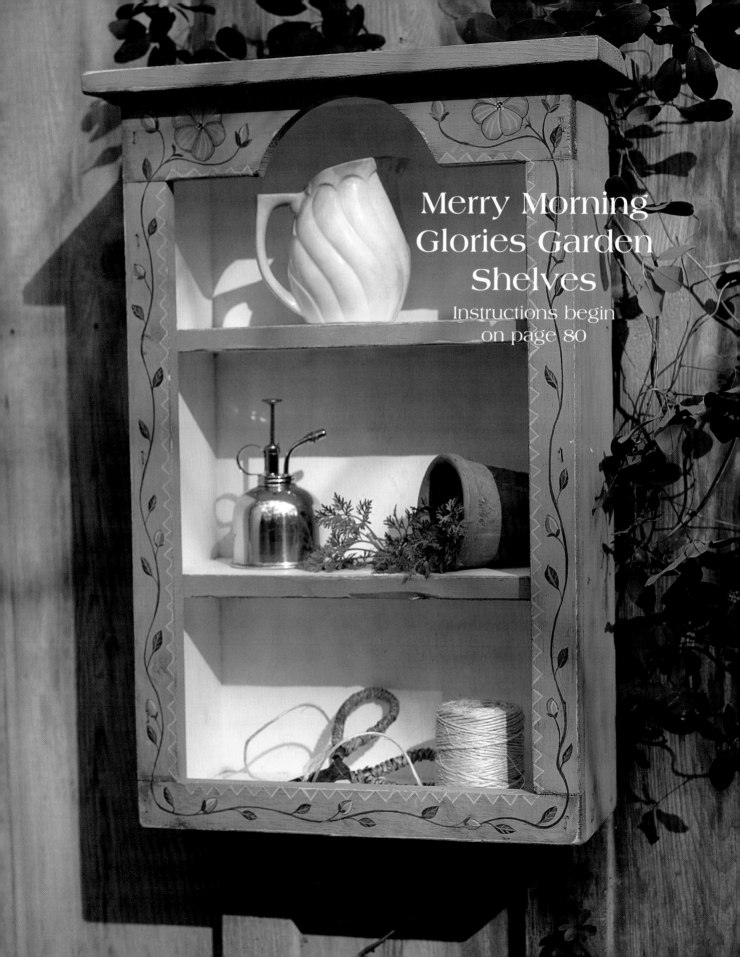

Merry Morning
Glories Garden
Shelves
Instructions begin
on page 80

Merry Morning Glories Garden Shelves

Pictured on page 79

Designed by
Kathleen Taylor

GATHER THESE SUPPLIES

Project Surface:
Wooden cupboard, approx. 18"
 tall x 10½" wide x 4" deep

Acrylic Craft Paints:
Baby Blue
Blue Ink
Buttercup
Evergreen
Green Meadow
Hauser Green Light
Light Periwinkle
Mint Green
Purple Lilac
Raw Umber
Shamrock
Sterling Blue
Wicker White
White

Brushes:
Flats: #4, #6, #10, #14
Liner: #10/0
Sponge brush: 2"
Stencil: ½"

Other Supplies:
Craft knife
Cutting surface
Outdoor sealer, satin
Sandpaper, 150-grit
Stencil blank
Transfer tools

INSTRUCTIONS

Prepare:
1. Refer to Surface Preparation on pages 6–10. Prepare cupboard.

2. Using sponge brush, base-coat outside of cupboard with Mint Green. Let dry.

3. Paint inside of cupboard with White.

4. Using #14 flat, paint edges of shelves, top, and inside of shelf opening with Purple Lilac.

5. Refer to How to Paint Your Project on page 11. Transfer Merry Morning Glories Patterns on page 81 onto cupboard.

6. Refer to How to Cut a Stencil on page 22. Transfer Sawtooth Border Pattern onto stencil blank. Cut out sawtooth stencil.

7. Refer to How to Use Special Finishing Techniques on page 25. Sand edges of shelves and the White painted interior for a rustic look.

Paint the Design:
Sawtooth Border:
1. Refer to How to Stencil on page 23. Using stencil brush and sawtooth stencil, stencil border around cupboard opening with Purple Lilac. Let dry.

2. Using liner, outline border with Purple Lilac plus a little Wicker White.

Vines, Leaves & Calyxes:
1. Refer to Decorative Painting on pages 12–21. Using #6 flat, paint vines and stems with Green Meadow.

2. Base-coat leaves with Shamrock.

3. Using #10 flat, shade one side of each leaf with wash of Evergreen.

4. Using liner, add veins with Hauser Green Light.

5. Paint calyxes with Shamrock. Let dry.

Morning Glories & Buds:
1. Using #6 flat, base-coat morning glories and buds with Light Periwinkle.

2. Using #10 flat, float shade around each petal with wash of Sterling Blue.

3. Using #4 flat, paint morning glory centers with Blue Ink.

4. Using liner, add dots in centers with Buttercup.

5. Stripe each petal with a wash of Baby Blue.

6. Outline each petal with Raw Umber.

7. Using #10 flat, highlight one side of each bud with wash of Baby Blue.

8. Using #4 flat, shade other side of each bud with wash of Sterling Blue.

Finish:
1. Using sponge brush, apply outdoor sealer.

Merry Morning Glories Patterns

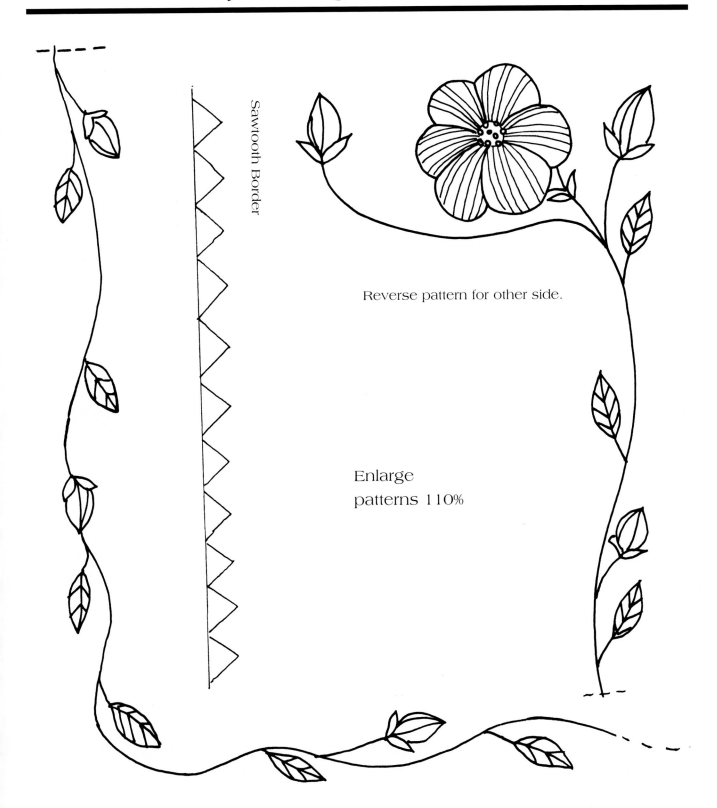

Sawtooth Border

Reverse pattern for other side.

Enlarge
patterns 110%

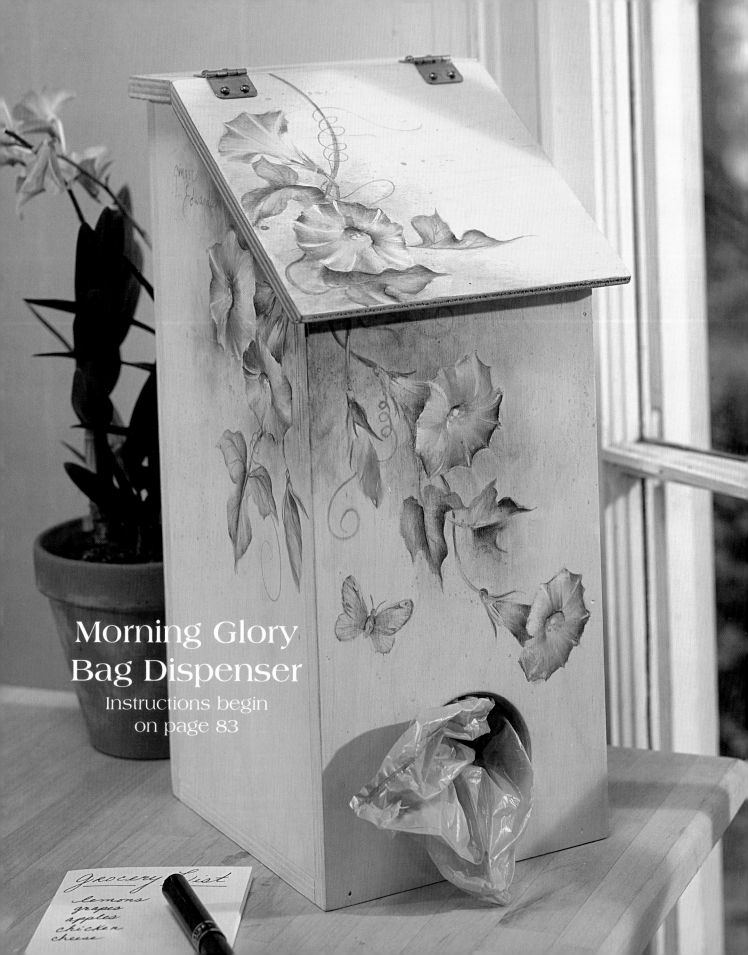

Morning Glory
Bag Dispenser
Instructions begin
on page 83

Morning Glory Bag Dispenser

Pictured on page 82

Designed by
Ginger Edwards

GATHER THESE SUPPLIES

Project Surface:
Wooden bin-type box with hinged lid and round opening, approx. 12½" tall x 6⅛" wide x 5½" deep

Acrylic Craft Paints:
Acorn Brown
Burnt Umber
Hauser Green Light
Ivory White
Lemon Custard
Lemonade
Maple Syrup
Periwinkle
Raspberry Wine
Thicket
Thunder Blue
Wicker White

Brushes:
Flats: #8, #10, #12
Liners: #10/0, #1
Sponge brush: 1"

Other Supplies:
Sandpaper, 220-grit
Tack cloth
Transfer tools
Water-based varnish
Wood sealer

INSTRUCTIONS

Prepare:
1. Refer to Surface Preparation on pages 6–10. Prepare box.

2. Using sponge brush, base-coat outside of box and lid with Ivory White plus wood sealer at a ratio of 1:3.

Note: This will give a pickled look.

3. Base-coat inside of box and lid with Periwinkle plus wood sealer at a ratio of 1:3. Let dry.

4. Refer to photograph on page 82 as a guide. Brush thinned Periwinkle on outside edges of lid, top edges of box, and inside edges of round opening.

5. Refer to How to Use Special Finishing Techniques on page 25. Sand to smooth surface and to expose some wood grain. Tack away dust.

6. Refer to How to Paint Your Project on page 11. Transfer Morning Glory Patterns on pages 84–85 onto lid, front, and left side of box.

Paint the Design:
Note: Thin base-coat paints with water so wood will show through and add dimension.

Base-coat:
1. Refer to Decorative Painting on pages 12–21. Using #8 and #12 flats, base-coat morning glories with Lemonade plus Wicker White.

2. Paint inside throats and bases of morning glories with Periwinkle.

3. Base-coat leaves, calyxes, and tendrils with Thicket.

4. Base-coat butterfly body with Acorn Brown plus Ivory White.

Morning Glories:
1. Using #8 flat, shade and add tints inside throats with a small amount of Burnt Umber and/or Burnt Umber plus Acorn Brown. Add tints to some areas with a tiny amount of Hauser Green Light.

2. Shade morning glories with Periwinkle plus a small amount of Thunder Blue.

3. Add tints with Periwinkle plus a small amount of Raspberry Wine.

4. Highlight with Wicker White plus Ivory White.

5. Using #1 liner, add dots in throats with Lemonade.

Leaves, Stems, Calyxes & Tendrils:
1. Using flat brushes, shade leaves, stems, calyxes, and tendrils with Thicket plus Thunder Blue.

2. Add tints with Thunder Blue plus Periwinkle.

3. Highlight with Hauser Green Light plus Lemonade. Intensify highlights with this mixture plus Ivory White.

4. Using liner brushes, add center veins with Hauser Green Light plus Lemonade plus Ivory White. Add side veins with Thicket plus Hauser Green Light.

5. Paint tendrils with thinned Thicket plus a speck of Thunder Blue.

Butterfly:

1. Using #8 flat side-loaded with Periwinkle, shade butterfly wings. Shade wings next to body.

2. Side-load brush with Lemon Custard and paint outer areas of wings. Let dry.

Tip: This works better if surface is premoistened.

3. Using #10 flat, deepen color on wing tips with transparent Acorn Brown.

4. Using #10/0 liner, paint wing markings with thinned Burnt Umber plus Maple Syrup. Do not overdo detailing.

5. Paint antennae with Burnt Umber plus Maple Syrup.

6. Using #8 flat, shade body with Maple Syrup plus Burnt Umber. Let Dry.

Background:

1. Using flat brushes, shade background around design with wash of Periwinkle plus a tiny amount of Thunder Blue, or Periwinkle plus a tiny amount of Raspberry Wine. Let dry.

Finish:

1. Using sponge brush, apply varnish.

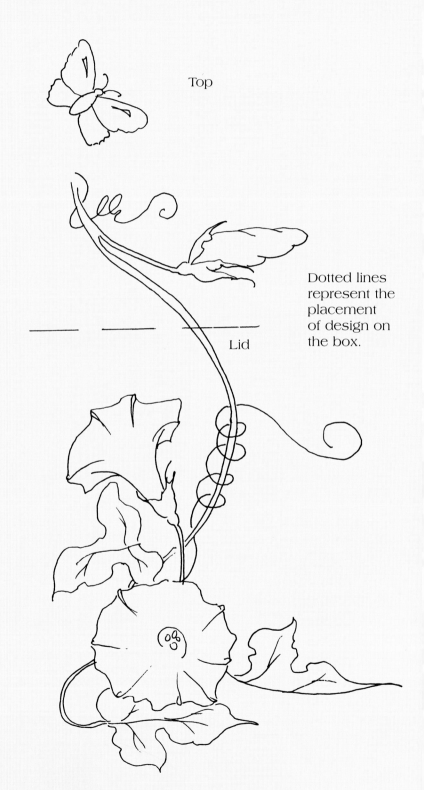

Top

Lid

Dotted lines represent the placement of design on the box.

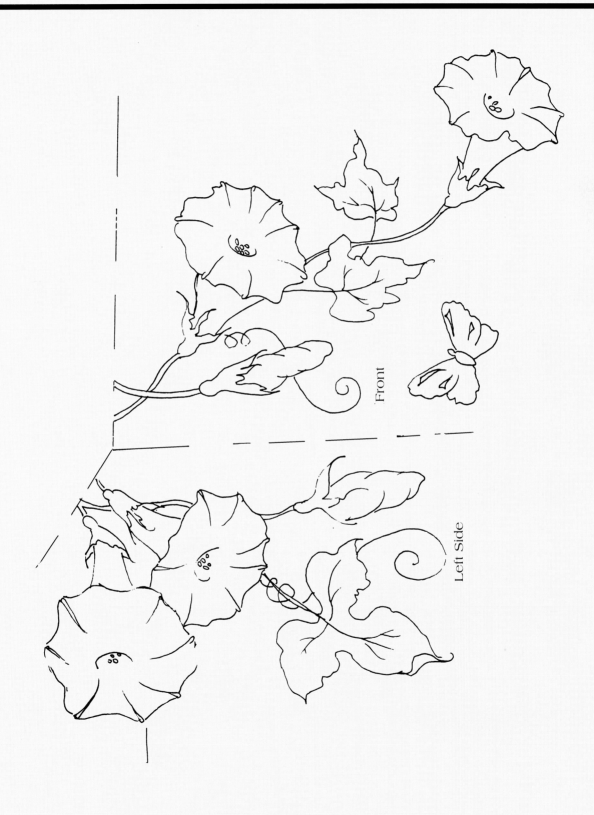

Front

Left Side

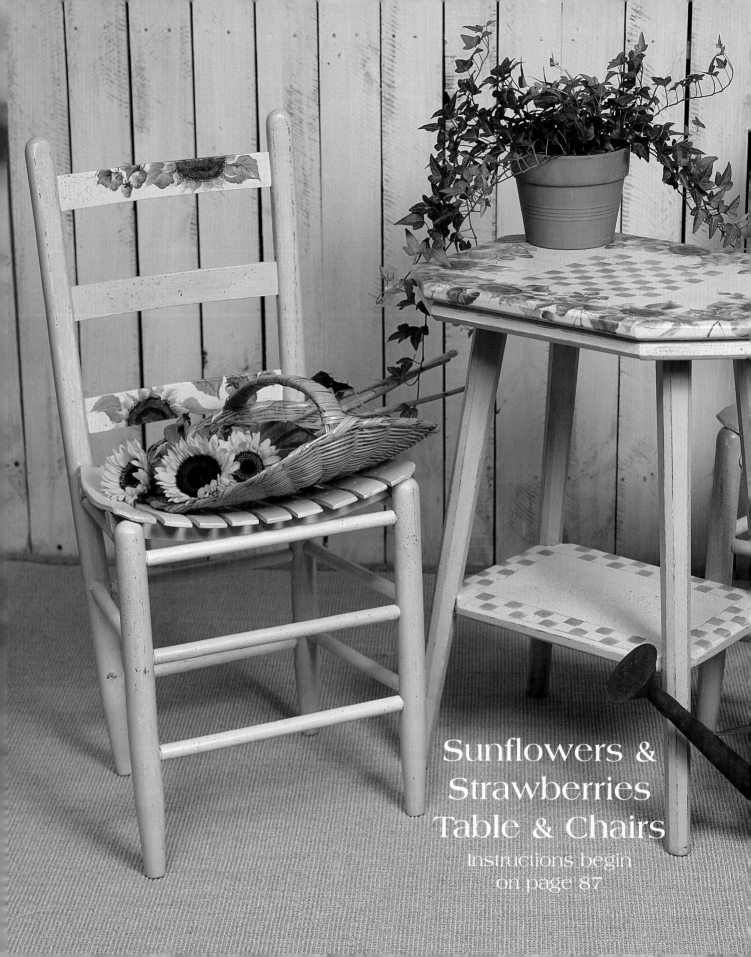

Sunflowers &
Strawberries
Table & Chairs
Instructions begin
on page 87

Sunflowers & Strawberries Table & Chairs

Pictured on page 86

Designed by
Chris Stokes

GATHER THESE SUPPLIES

Project Surfaces:
Wooden chairs
Wooden table with shelf,
 17" tall x 23" wide

Acrylic Craft Paints:
Apple Spice
Burnt Sienna
Burnt Umber
Buttercream
Christmas Red
Old Ivy
Parchment
Wrought Iron
Yellow Light

Brushes:
Flat: #8, #10
Old toothbrush
Round: #5
Script liner: #1
Sponge brush: 2"
Stencil: ⅜", 1"

Other Supplies:
Crackle medium
Craft knife
Cutting surface
Latex paints that match:
 Turner's Yellow; Parchment
Low-tack masking tape, ¾"
 wide
Sandpaper, 220-grit
Stencil blank
Stylus
Tack cloth
Transfer tools
Water-based varnish

INSTRUCTIONS

Prepare:
1. Refer to Surface Preparation on pages 6–10. Prepare chairs and table.

2. Refer to photograph on page 86 as a guide. Using sponge brush, base-coat table and chairs with Turner's Yellow and Parchment-colored latex paint. Apply as many coats as necessary to achieve solid coverage. Let dry and sand between coats.

3. Refer to How to Use Special Painting Techniques on page 24. Mix crackle medium with Parchment acrylic craft paint. Paint tabletop and lower shelf. Let dry.

4. Refer to How to Cut a Stencil on page 22. Transfer checkerboard pattern onto stencil blank. Cut out checkerboard stencil.

Paint the Design:
Background Leaves:
Note: The following technique gives depth and realism.

1. Refer to How to Paint Your Project on page 11. Transfer Sunflowers & Strawberries Patterns on page 89 onto table and chairs.

2. Refer to Decorative Painting on pages 12–21. Using 1" stencil brush, dry-brush design area with a little Burnt Umber plus Old Ivy and touches of Apple Spice.

3. Using #8 and #10 flats, base-coat leaves with with a wash of burnt Umber plus Old Ivy and touches of Apple Spice.

Sunflowers:
1. Using ⅜" stencil brush, pounce sunflower centers with Burnt Umber and Burnt Sienna. Deepen shading in centers with Wrought Iron. Let dry.

2. Using #8 flat double-loaded with Burnt Sienna and Yellow Light, pull bottom petals out from sunflower center and pull to a point. Let dry.

3. Double-load brush as in previous step, then tip in Parchment on yellow side of brush. Pull top petals out. Let dry.

4. Using script liner, shade with Burnt Sienna.

5. Add detail with Parchment.

6. Using stylus, add dots around centers with Burnt Umber.

Strawberries:
1. Using ⅜" stencil brush double-loaded with Buttercream and Christmas Red, pounce to blend. Holding brush vertically, touch brush to surface and twist, keeping light area on left. Let dry.

2. Using #8 flat, shade strawberries with Apple Spice.

3. Using script liner, add dots for seeds with Burnt Umber.

4. Highlight strawberries with Parchment.

5. Paint stems with Burnt Umber plus a touch of Old Ivy.

Foreground Leaves & Twigs:
1. Using #8 and #10 flats doubled-loaded with Old Ivy and Yellow Light plus a touch of Parchment, paint some leaves. Paint some leaves with this mixture and touches of Apple Spice.

2. Using round brush, add details on some leaves with thinned Old Ivy plus Parchment and on others with thinned Burnt Umber.

3. Paint twigs, stems, and tendrils with leaf-detail mixtures.

Checkerboard :
1. Tape checkerboard stencil into place on tabletop.
 Option: Use masking tape to tape off checker pattern.

2. Refer to How to Stencil on page 23. Using 1" stencil brush and checkerboard stencil, stencil checkerboard with Old Ivy plus Yellow Light on tabletop and around outer edge of shelf.

3. Using script liner, wiggle in border lines on checkerboard with inky Burnt Umber. Let dry.

Finish:
1. Using old toothbrush, spatter tabletop with inky Burnt Umber. Let dry.

2. Refer to How to Use Special Finishing Techniques on page 25. Sand edges for a worn, antique look. Tack away dust.

3. Using sponge brush, apply several coats varnish.

Sunflowers & Strawberries Table Closeup

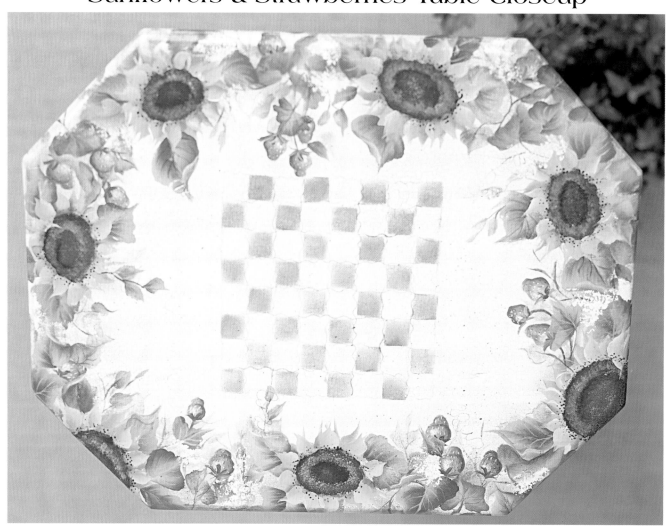

Sunflowers & Strawberries Patterns

Tabletop (repeat)

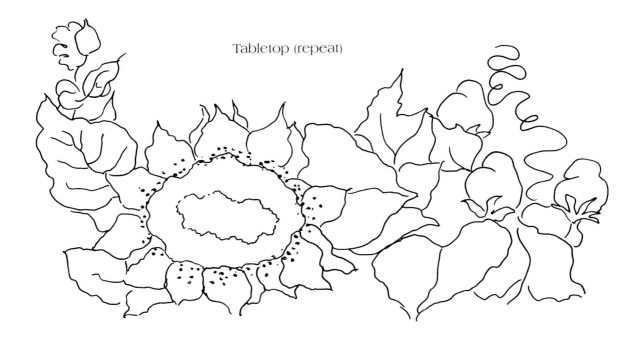

Enlarge
patterns 155%

Chair (repeat)

Coneflower Butterfly House

Pictured on page 91

Designed by
Faith Rollins

GATHER THESE SUPPLIES

Project Surface:
Wooden butterfly house with
copper roof, approx. 21" tall
x 4¾" wide x 5" deep

Acrylic Craft Paints:
Bluebonnet
Burnt Sienna
Burnt Umber
Cappuccino
Coffee Bean
Hauser Green Light
Hauser Green Medium
Indigo
Licorice
Poppy Red
Raspberry Wine
Tapioca
Thicket
Thunder Blue
Turner's Yellow
Wicker White
Wrought Iron

Brushes:
Filberts: #2, #10
Flat: #10
Script liner: #6/0
Sponge brush: 2"
Stencil: ½"

Other Supplies:
Acrylic sealer, matte
Craft knife
Cutting surface
Sandpaper, 220-grit
Stencil blank
Transfer tools

INSTRUCTIONS

Prepare:
1. Refer to Surface Preparation
on pages 6–10. Prepare butter-
fly house.

2. Using sponge brush, paint
house and latch with one coat
of thinned Thicket. Let dry,
then sand.

*Note: Do not paint copper
roofs. Copper will darken into
a characteristic copper patina
provided it is not sealed.*

3. Paint trim below roofs with
Thunder Blue. Shade trim with
Indigo.

4. Refer to How to Cut a Sten-
cil on page 22. Transfer
checker pattern from Cone-
flower Patterns on pages
92–95 onto stencil blank. Cut
out checker stencil.

Paint the Design:
Checkers:
1. Refer to How to Stencil on
page 23. Using stencil brush
and stencil, stencil checkers
on house front, back, and
sides with Tapioca.

2. Refer to photograph on
page 91 as a guide. Using
stencil brush, shade left side
and bottom of checkers with
Coffee Bean.

3. Using script liner, paint strip
above checkers on front and
sides with Thunder Blue.

4. Using flat brush, shade
above and below strip with
Wrought Iron.

Coneflowers:
1. Refer to How to Paint Your
Project on page 11. Transfer
Coneflower Patterns onto
butterfly house.

2. Refer to Decorative Painting
on pages 12–21. Using filbert
brushes, paint coneflower
petals with two coats of
Poppy Red.

3. Using flat brush, shade
petals with wash of Raspberry
Wine plus Poppy Red. Deepen
shading with another wash of
Raspberry Wine.

4. Using script liner, add veins
in petals with thinned Rasp-
berry Wine.

5. Using flat brush, highlight
petals with Cappuccino.

6. Using #2 filbert, shade
center of petals with Burnt
Umber.

7. Shade coneflower centers
with Turner's Yellow.

8. Paint center indents with
Burnt Umber.

9. Using tip of script liner, dab
coneflower centers with thin-
ned Burnt Umber.

10. Highlight around indents
with float of thinned Turner's
Yellow plus Wicker White.

Leaves & Stems:
1. Using filbert brushes, base-
coat leaves and stems with
two coats of Hauser Green
Medium.

2. Using flat brush, shade with
float of Wrought Iron.

Continued on page 92

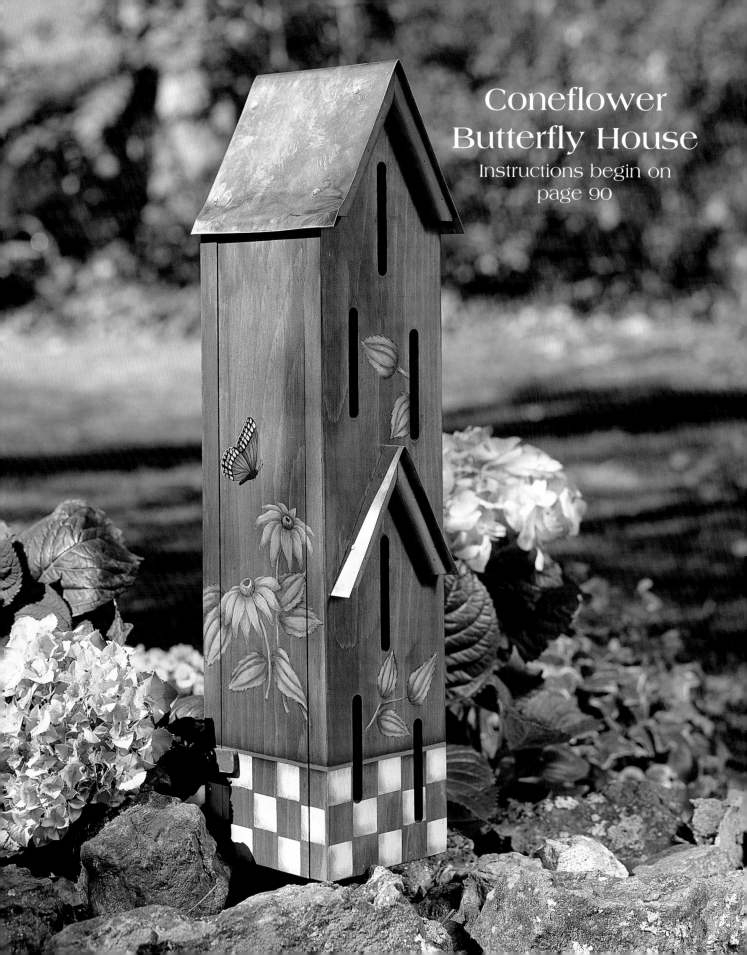

Coneflower
Butterfly House
Instructions begin on
page 90

Continued from page 90

3. Highlight with float of Hauser Green Light. Intensify highlight with dry-brush of Hauser Green Light plus a touch of Wicker White.

4. Using script liner, loosely outline leaves and stems with thinned Wrought Iron.

Butterflies:
1. Using filbert brushes, base-coat butterfly wings with Coffee Bean plus a touch of Burnt Umber.

2. Using flat brush, highlight with Burnt Sienna. Intensify highlight with Burnt Sienna plus a touch of Turner's Yellow.

3. Shade between wing sect-ions and next to body with float of Burnt Umber.

4. Using script liner, paint upper section of wings with Licorice.

5. Using #2 filbert, paint first row of crescents in upper section of wing with Turner's Yellow. Paint next row with Thunder Blue. Paint third row with Turner's Yellow. Add second coat of each color.

6. Using flat brush, highlight Turner's Yellow crescents with float of Wicker White plus Turner's Yellow.

7. Highlight Thunder Blue crescents with float of Wicker White plus Bluebonnet.

8. Using script liner, paint along top edge of wing sections with thinned Wicker

White. When dry, tone down Wicker White with a touch of very thin Coffee Bean.

9. Add veins and body with Licorice.

10. Add stripes on body with thinned Thunder Blue plus a touch of Licorice.

11. Add antennae and legs with Licorice.

12. Add eye with thinned Thunder Blue.

Finish:
1. Using stencil brush, spatter with Licorice. Let dry.

2. Spray with acrylic sealer.

Coneflower Patterns

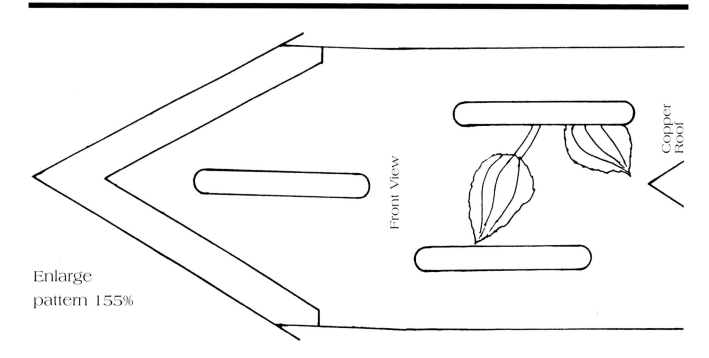

Front View

Copper Roof

Enlarge pattern 155%

92

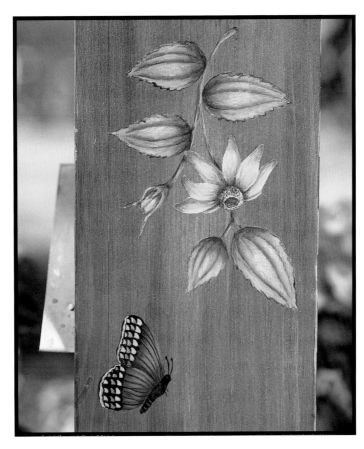

Close up of cone-
flower and butterfly
detail.

Coneflower Patterns

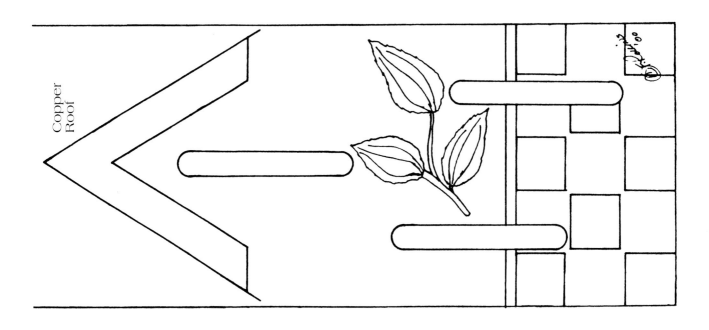

Copper
Roof

Right Side View

Left Side View

Side section hinge pins

Coneflower Patterns

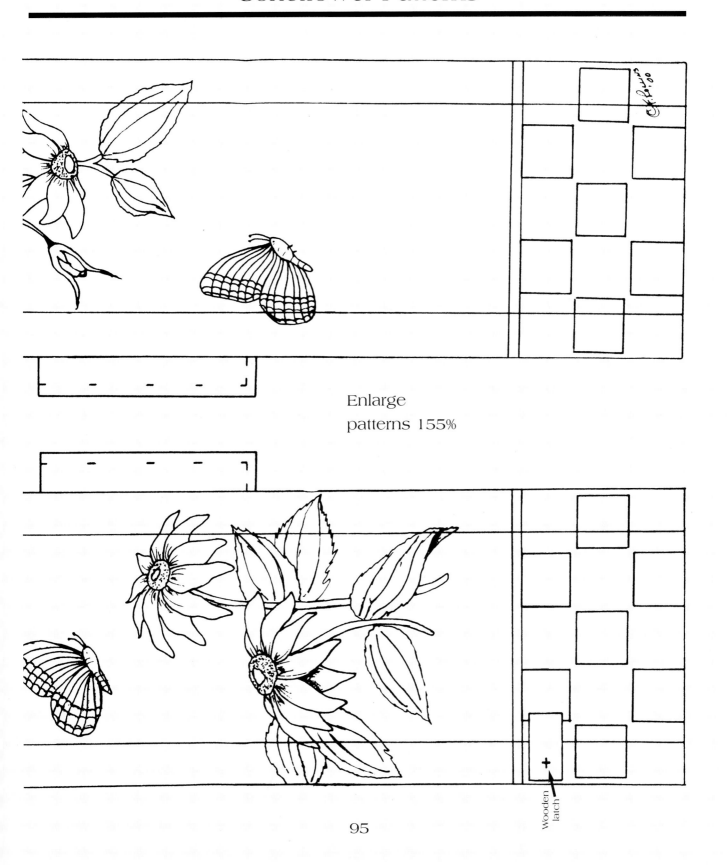

Enlarge
patterns 155%

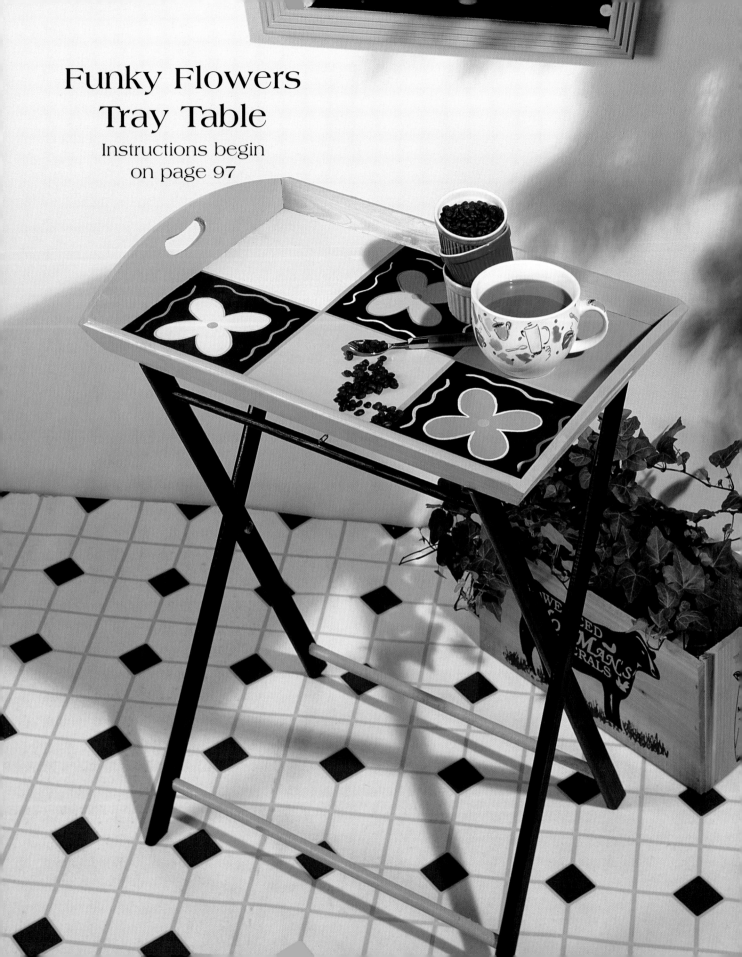

Funky Flowers
Tray Table

Instructions begin
on page 97

Funky Flowers Tray Table

Pictured on page 96

Designed by
Holli Long

GATHER THESE SUPPLIES

Painting Surface:
Wooden tray table, approx. 20"
 tall x 29" wide

Indoor/Outdoor Acrylic Paints:
Antique White
Black
Lanier Blue
Pink Rose
Spring Green

Brushes:
Liner: #1
Round: #3
Sponge brush: 1"

Other Supplies:
Low-tack masking tape,
 ½" wide
Pencil
Ruler
Transfer tools

INSTRUCTIONS

Prepare:
1. Refer to Surface Preparation on pages 6–10. Prepare tray table.

2. Using sponge brush, paint base with Black. Paint lower stretchers and small wooden knobs on insides of legs with Spring Green.

3. Paint sides and bottom of tray with Spring Green. Let dry.

4. Refer to photograph on page 96 as a guide. Using ruler and pencil, divide bottom of tray into six sections. Mask off ½"-wide lines between sections.

5. Using round brush, paint lines with Spring Green. Remove tape. Let dry.

6. Position masking tape on lines around three sections, then paint sections with Black. Remove tape. Let dry.

7. Mask off remaining sections. Paint one with Lanier Blue, one with Pink Rose, and one with Antique White. Remove tape. Let dry.

Painting the Design:
Flowers:
1. Refer to How to Paint Your Project on page 11. Transfer Funky Flowers Pattern below onto black sections.

2. Refer to Decorative Painting on pages 12–21. Using round brush, paint flowers. Match the paint color of flower to adjacent section. Let dry.

3. Paint flower centers with Spring Green.

4. Using liner, outline Antique White flower with Pink Rose. Outline Pink Rose flower with Lanier Blue. Outline Lanier Blue flower with Antique White.

5. Paint wavy lines around Antique White flower with Lanier Blue. Paint wavy lines around Pink Rose flower with Antique White. Paint wavy lines around Lanier Blue flower with Pink Rose.

Funky Flowers Pattern

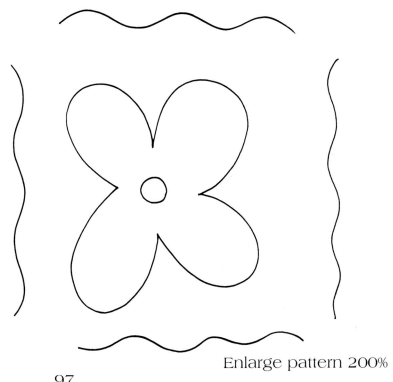

Enlarge pattern 200%

Country Mirror

Instructions begin
on page 99

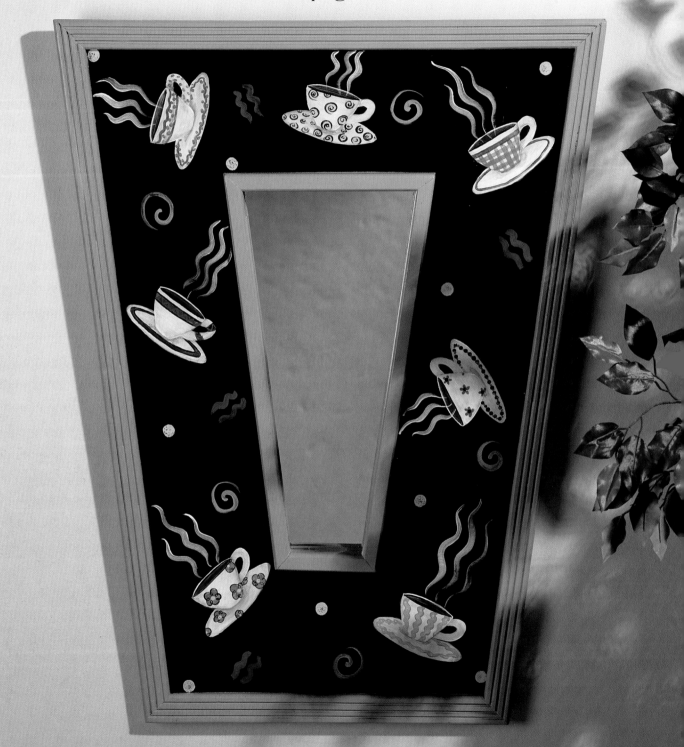

Country Mirror

Pictured on page 98

Designed by
Kathi Malarchuk

GATHER THESE SUPPLIES

Project Surface:
Mirror with wide unfinished
wooden frame, approx.
36" tall x 28" wide

Indoor/Outdoor Acrylic Paints:
Black
Dandelion Yellow
Deep Purple
Mocha
Pinwheel Blue
Raspberry
Spring Green
White

Brushes:
Flat: #8
Foam pouncing tool: ¾"
Sponge brush: 1"
Stencil: ½"

Other Supplies:
Craft knife
Cutting surface
Masking tape
Sandpaper, 220-grit
Stencil blank
Tack cloth
Transfer tools
White spray primer
Neutral-colored latex wood filler

INSTRUCTIONS

Prepare:
1. Refer to Surface Preparation on pages 6–10. Prepare mirror and frame.

2. Fill in any nail holes, cracks or gaps with neutral-colored latex wood filler. Let dry, then sand smooth.

3. Mask entire mirror with masking tape.

4. Spray frame with primer, following manufacturer's instructions.

Note: Apply sufficient coats to prevent dark areas of wood from showing through.

5. Refer to How to Cut a Stencil on page 22. Transfer Country Mirror Patterns below onto stencil blank. Cut out coffee cup stencils.

Paint the Design:
Base-coat:
1. Refer to photograph on page 98 as a guide. Using sponge brush, paint frame with Black. Let dry.

2. Paint trim on inner and outer edges with Spring Green. Let dry.

Cups & Saucers:
1. Refer to How to Stencil on page 23. Using pouncing tool and coffee cup stencils, randomly stencil cups and saucers on Black area of frame with White. Let dry.

2. Stencil coffee inside cups with Mocha. Let dry.

3. Refer to Decorative Painting on pages 12–21. Using stencil brush, shade bottoms of cups and handles with Pinwheel Blue.

4. Using flat brush, add details on cups with Spring Green, Black, Dandelion Yellow, Pinwheel Blue, Raspberry, and Deep Purple.

5. Add wavy lines above cups with White.

6. Randomly add pairs of wavy lines with Raspberry.

7. Randomly add swirls with Spring Green.

8. Using handle end of brush, randomly add dots with Dandelion Yellow.

Country Mirror Patterns

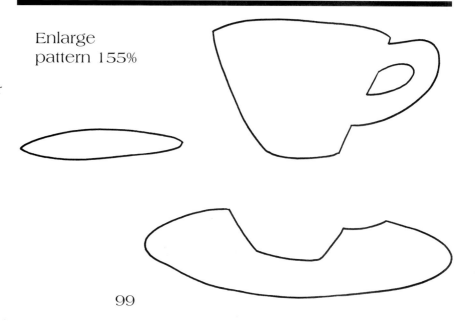

Enlarge
pattern 155%

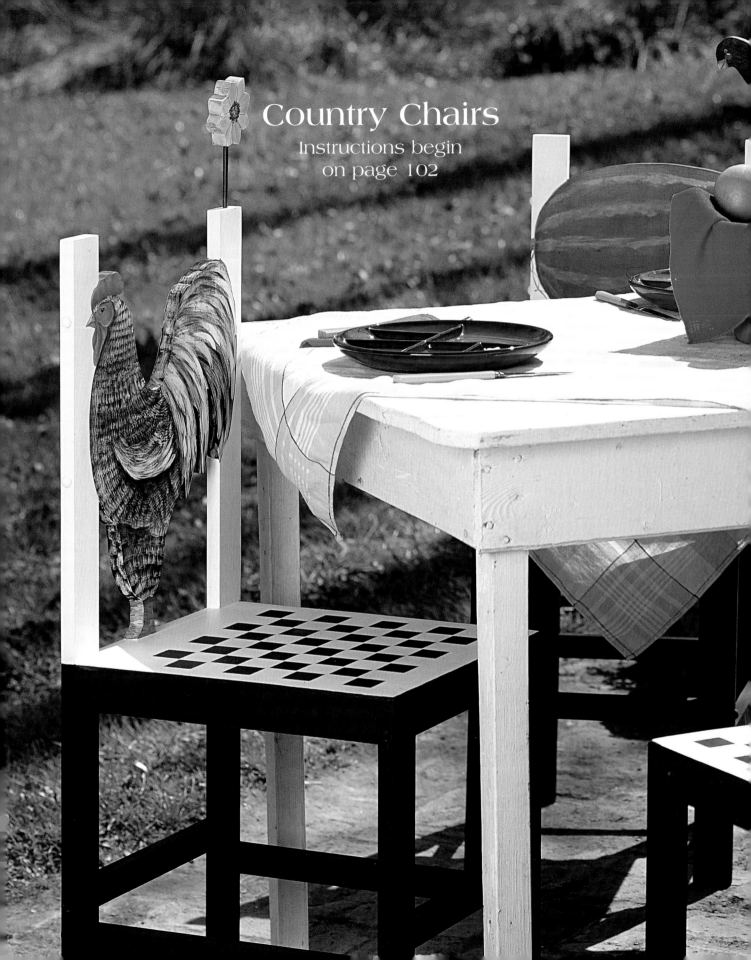

Country Chairs

Instructions begin
on page 102

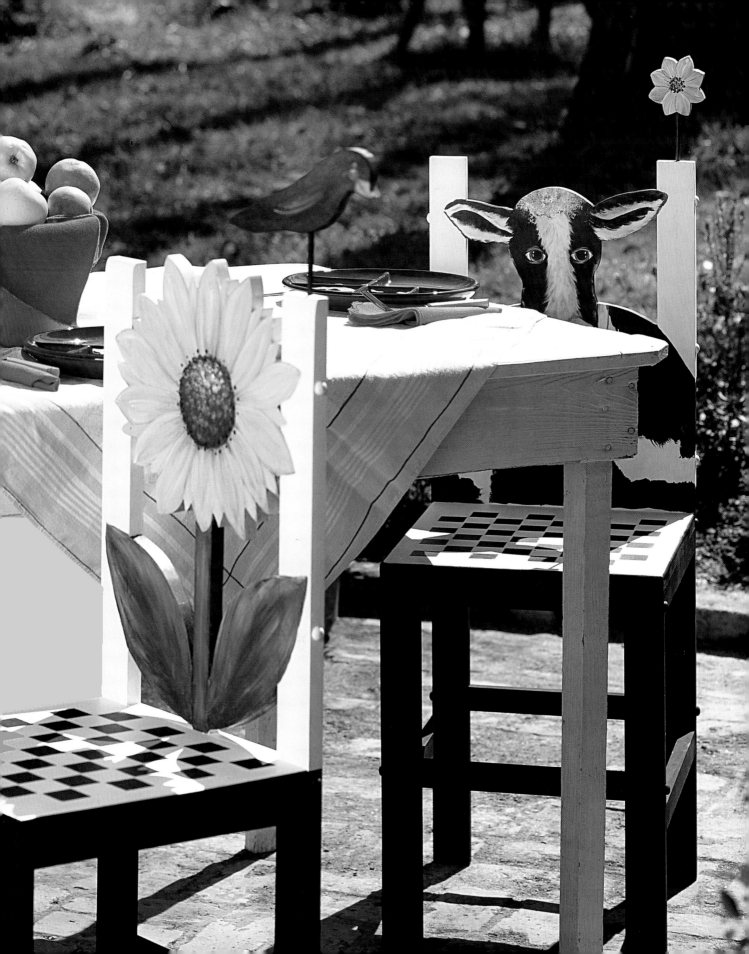

Country Chairs

Pictured on pages 100–101

Designed by
Sue Bailey

GATHER THESE SUPPLIES

Project Surfaces:
Set of four wooden chairs
(Chairs can be handmade,
using patterns for back motif.)
Two wooden birds on dowels
 approx. 3"–4" tall
Two wooden sunflowers on
 dowels approx. 3"–4" tall

Acrylic Craft Paints:
Alizarin Crimson
Burnt Sienna
Burnt Umber
Hunter Green
Napthol Crimson
Portrait Light
Pure Black
Raw Sienna
Red Light
Titanium White
Yellow Light

Brushes:
Flats: #2, #8, #10, #16, #20
Liner: #10/0
Sponge brush: 1"

Other Supplies:
Checkerboard stencil with 1½"
 squares (optional)
Low-tack masking tape,
 ¾" wide
Permanent marker, black
Transfer tools
Water-based varnish, satin

INSTRUCTIONS

Prepare:
1. Refer to Surface Preparation
on pages 6–10. Prepare
chairs.

2. Using sponge brush, base-
coat seat top and chair back
with Titanium White.

3. Base-coat seat rim, legs,
and rungs with Pure Black.
Let dry.

Paint the Design:
Seats:
1. Refer to photograph on
page 105 as a guide. Refer to
How to Stencil on page 23.
Tape checkerboard stencil into
place on seat. Using sponge
brush, stencil seats with Pure
Black.
 Option: Use masking tape to
tape off checker pattern.

2. Refer to How to Paint Your
Project on page 11. Transfer
Country Chairs Patterns on
pages 103–108 onto front and
back of each chair back.

**Blackbirds (On Watermelon
and Sunflower Chairs):**
1. Refer to Decorative Painting
on pages 12–21. Using #16
flat, base-coat birds with Pure
Black. Highlight wings with
Titanium White.

2. Using #10 flat, paint beaks
with Yellow Light. Shade with
Burnt Umber. Highlight with
Titanium White.

3. Using #2 flat, add large Raw
Sienna dot for each eye. High-
light each with a small dot of
Titanium White.

4. Add cheeks with Napthol
Crimson. Highlight with
Titanium White.

**Small Sunflowers (On Cow
and Rooster Chairs):**
1. Using #16 flat, base-coat
sunflowers with Burnt Sienna.

2. Using #8 flat, paint petals,
following instructions for Large
Sunflower Step 3 below.

3. Paint sunflower center with
Burnt Umber. Dab on Burnt
Sienna, then Yellow Light, then
Yellow Light plus Titanium
White. Add dots around cen-
ters with Pure Black. Let dry.

4. Using liner, add lines be-
tween petals with Pure Black.

5. Using #10 flat, paint stems
Hunter Green.

Large Sunflower:
1. Using #20 flat, base-coat
sunflower with Burnt Sienna.

2. Retransfer sunflower pattern
if necessary.

3. Using #16 or #20 flat, pull
from outer edge inward with
Yellow Light, then with Yellow
Light plus Titanium White. Let
Burnt Sienna show through in
some places.

4. Dab Burnt Umber on sun-
flower center, then dab Burnt
Umber plus Yellow Light, then
Yellow Light plus Titanium
White. Add dots around center
with Pure Black. Let dry.

5. Using permanent marker,
add lines between petals.

Leaves & Stem:
1. Using #16 or #20 flat, base-
coat with Hunter Green.

2. Highlight with Hunter Green
plus Yellow Light, then with
Yellow Light plus Titanium
White. Let dry

3. Using permanent marker,
add detail lines.

Continued on page 105

Country Chairs Sunflower Pattern

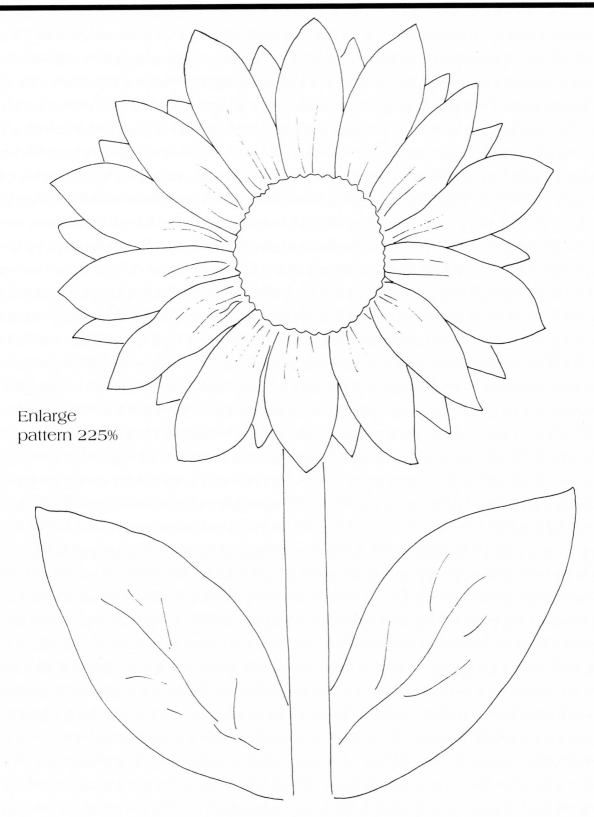

Enlarge
pattern 225%

Country Chairs Rooster Pattern

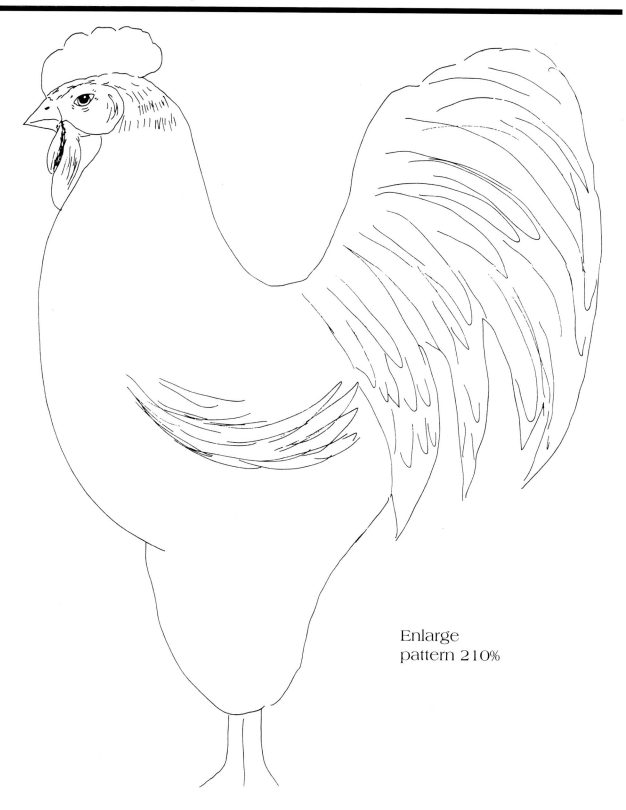

Enlarge
pattern 210%

Continued from page 102

Rooster:

1. Using #16 or #20 flat, base-coat body with Pure Black.

2. Dry-brush body feathers with Titanium White. Start at head and use short choppy over-lapping strokes, following contour of body.

3. Using chisel edge of brush and long sweeping strokes, add wing and tail feathers with Titanium White.

4. Shade under wing and stomach with Pure Black.

5. Using #10 flat, base-coat wattle, comb, and "face mask" with Red Light.

6. Shade wattle, comb, and "face mask" with Alizarin Crimson. Highlight with Red Light plus Titanium White.

7. Base-coat beak with Yellow Light.

8. Shade beak with Burnt Sienna. Highlight with Yellow Light plus Titanium White, then with Titanium White.

9. Add details with Pure Black.

10. Using #2 flat, base-coat eye with Raw Sienna. Let dry.

11. Add pupil and outline eye with Pure Black.

12. Add crescent shape at lower left corner of iris with Yellow Light.

13. Highlight pupil with dot of Titanium White. Add details around eye with Pure Black.

14. Using #10 flat, base-coat feet with Yellow Light.

15. Shade feet with burnt Sienna. Highlight with Yellow Light plus Titanium White.

16. Add details with Pure Black.

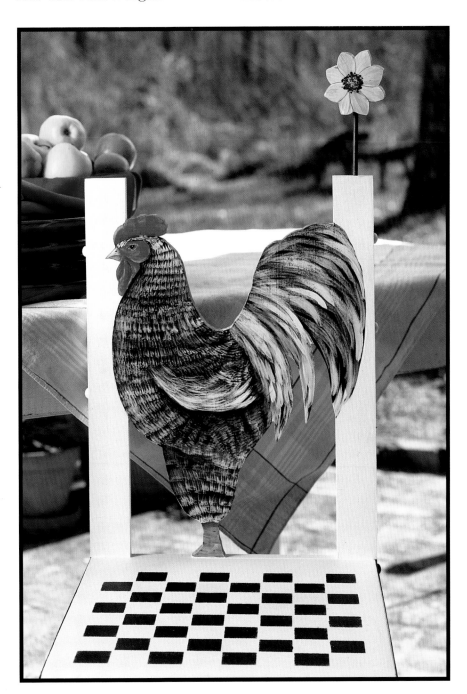

Whole Watermelon:
1. Using #16 or #20 flat, base-coat watermelon and vine with Hunter Green.

2. Highlight with Hunter Green plus Titanium White.

Watermelon Slice:
1. Paint outer rind with Hunter Green. Paint inner rind with Hunter Green plus Titanium White.

2. Base-coat meat portion of watermelon with Red Light. Dab on Napthol Crimson, then Napthol Crimson plus Alizarin Crimson, then Alizarin Crimson. Let dry.

3. Retransfer watermelon pattern if necessary.

4. Using #2 flat, paint seeds with Pure Black. Highlight with Titanium White.
Continued on page 109

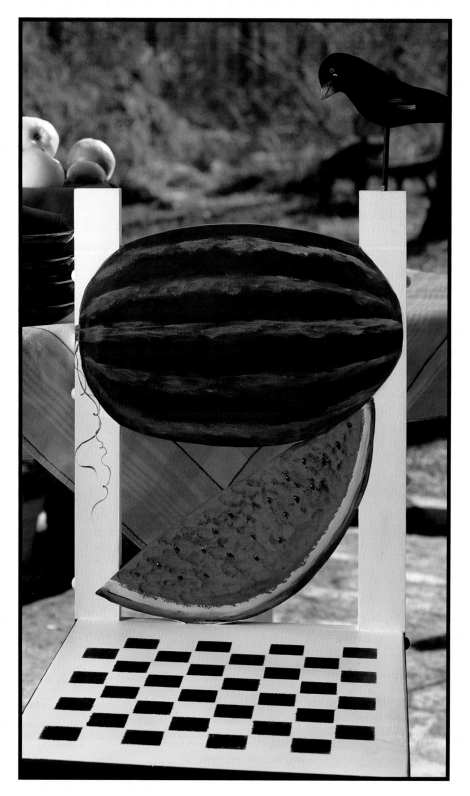

Country Chairs Watermelon Pattern

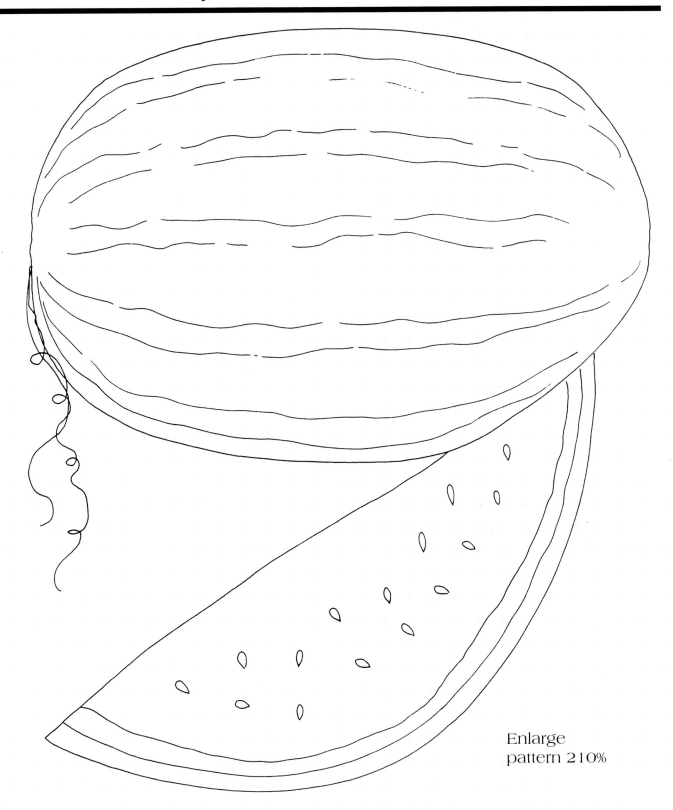

Enlarge
pattern 210%

Country Chairs Cow Pattern

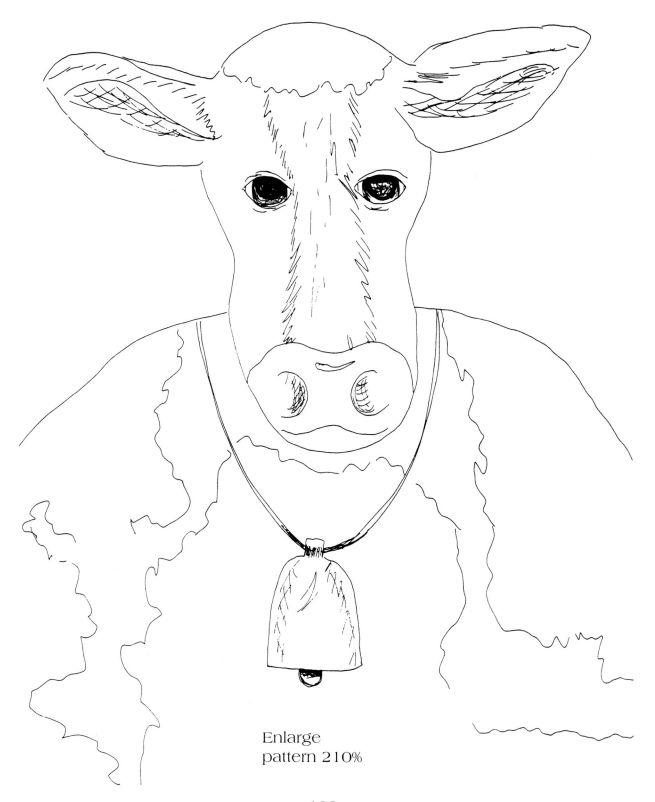

Enlarge
pattern 210%

Continued from page 106

Cow:

1. Using sponge brush, base-coat cow with Titanium White.

2. Retransfer cow pattern if necessary.

3. Using #16 or #20 flat, paint dark areas with Pure Black.

Note: Pull with very irregular strokes to suggest hair on body.

4. Using choppy strokes, paint top of head, ears, and bridge of muzzle with Titanium White plus Pure Black.

5. Using liner brush, add hair detail with Titanium White plus Pure Black.

6. Using #2 flat, outline eyes with Pure Black.

7. Add irises in eye with Burnt Sienna. Highlight with Titanium White.

8. Paint pupils with Pure Black. Add two dots on each pupil with Titanium White.

9. Highlight top and bottom of eyelids with Titanium White.

10. Using #16 flat, base-coat nose with Portrait Light.

11. Shade mouth area with Burnt Sienna.

12. Float inside nostrils with Burnt Sienna. Let dry.

13. Darken nose and mouth with Burnt Umber. Highlight between nostrils with Titanium White.

14. Add comma stroke highlight with Titanium White.

15. Base-coat bell with Yellow Light. Let dry.

16. Shade bell with Burnt Sienna. Highlight with Titanium White. Let dry.

Finish:

1. Using sponge brush apply several coats varnish.

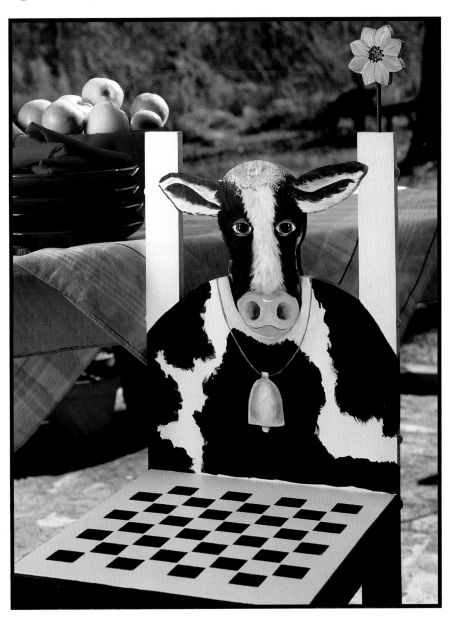

Trumpet Vine

Instructions begin
on page 111

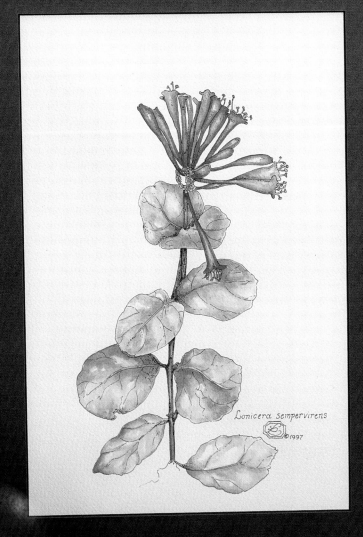

Lonicera sempervirens

© 1997

Trumpet Vine

Pictured on page 110

*Designed by
Dolores Lennon*

GATHER THESE SUPPLIES

Project Surface:
Watercolor paper, 13½" x 18"

Acrylic Craft Paints:
Burnt Sienna
Burnt Umber
Hauser Green Light
Holiday Red
Holly Leaf
Lipstick Red
Olive Green
Poppy Red

Brush:
Round, #8

Other Supplies:
Paper towel
Permanent ink pen: black, .25
Transfer tools
Water

INSTRUCTIONS

Prepare:
1. Refer to How to Paint Your Project on page 11. Transfer Trumpet Vine Patterns on page 112 onto watercolor paper.

Note: When transferring, press very gently so as not to make indentations on paper. Transfer as many fine detail lines as necessary.

Ink the Design:
1. Holding pen horizontally, gently rock it back and forth, being certain to hold it away from paper. Test the ink flow on a scrap of paper.

2. Place folded clean paper towel under inking hand.

Note: This prevents oil from skin from getting on paper and also helps keep paper clean.

3. Hold pen gently and allow hand to flow with the tracing.

4. Store pen in capped upright position.

Paint the Design:
Flowers:
1. Refer to Decorative Painting on pages 12–21. Using round brush, make washes of Poppy Red, Lipstick Red, and Holiday Red.

2. Dampen base, end, and both sides of flowers with clean water, leaving thin, tubular dry spot for lightest area. Apply Poppy Red wash, then Lipstick Red wash to dampened area. Let dry.

3. Dampen base and outer edges of flower with clean water. Apply tiny amount of Holiday Red wash. Let dry.

4. Make very pale wash of Holly Leaf. Redampen one side of flower with clean water. Apply Holly Leaf wash to gray-down intensity of Lipstick Red.

Leaves:
1. Make washes of Hauser Green Light, Olive Green, and Holly Leaf.

2. Dampen leaf with clean water, leaving some dry areas for highlights. Apply thin wash of Holly Leaf or Hauser Green Light, touching down color from tip of brush and allowing color to spread.

3. Apply wash of Olive Green to shadow areas and touch down color along edges to help create contouring on edges.

4. Apply Holly Leaf wash in shadow area and/or along edges of some leaves.

5. Apply washes of Burnt Sienna or pale Lipstick Red to accent leaves.

Stem:
1. Make washes of Burnt Sienna and Burnt Umber.

2. Dampen stem with clean water. Apply a wash of Burnt Sienna, then quickly apply a tiny amount of Burnt Umber wash along edges. Let dry completely.

Finish:
1. Re-ink or add further ink detail as desired.

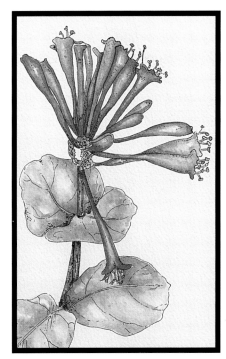

Trumpet Vine Patterns

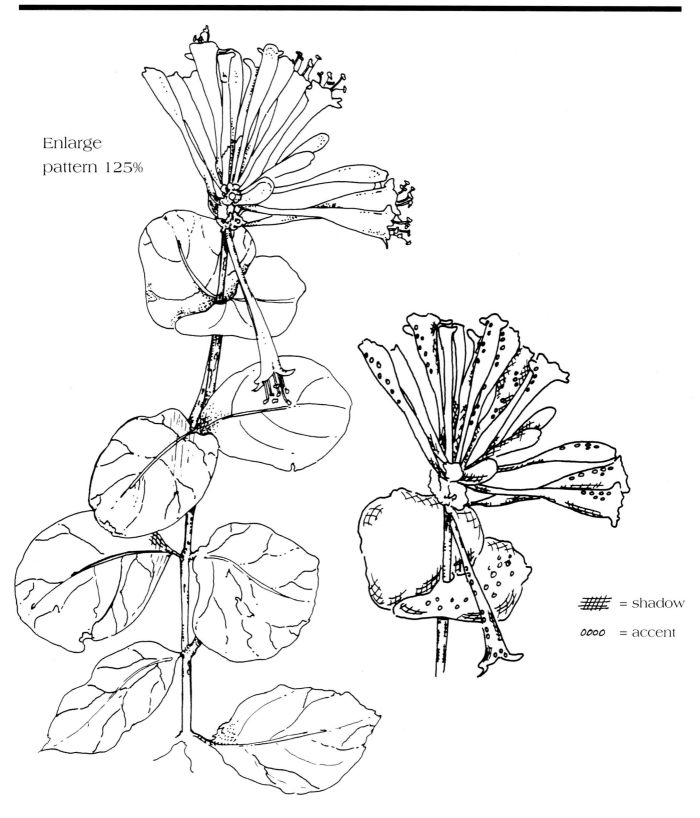

Enlarge
pattern 125%

⧗⧗⧗ = shadow

0000 = accent

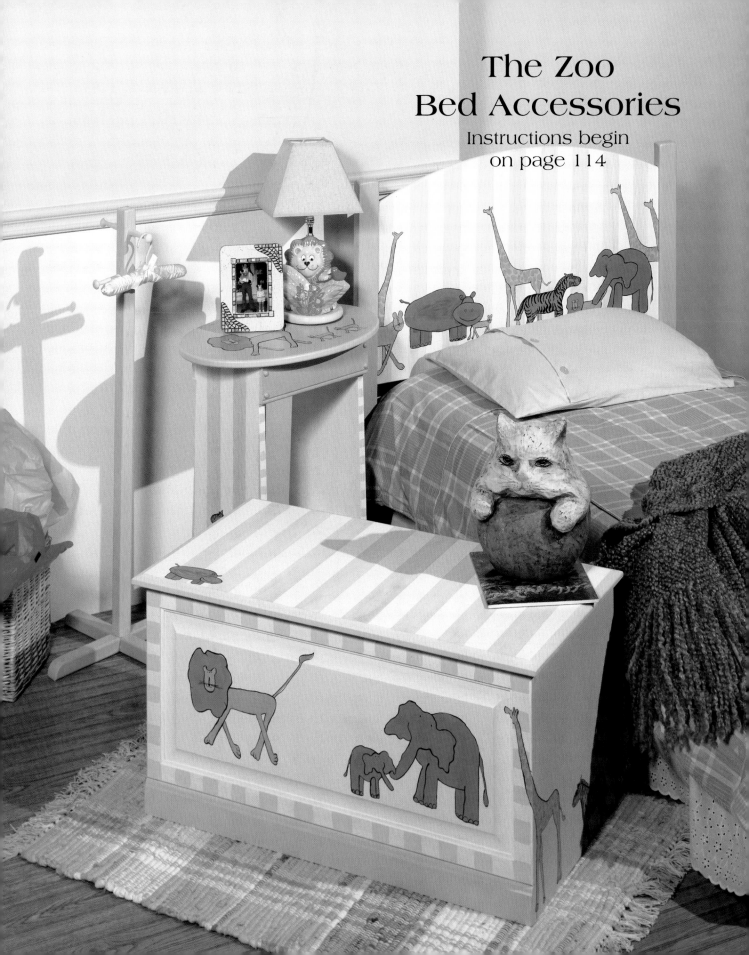

The Zoo
Bed Accessories

Instructions begin
on page 114

The Zoo
Bed Accessories

Pictured on page 113

Designed by
Alison Stillwell

*BED ACCESSORIES
PAINTING TIPS*

• *Use fun and different colors.*

• *Use a copy machine to make the animals different sizes.*

• *Make mirror images to face the animals in opposite directions.*

• *Be really brave and paint your own animals!*

The Zoo
Clothes Tree

Designed by
Alison Stillwell

GATHER THESE SUPPLIES

Project Surface:
Child's wooden clothes tree

Acrylic Craft Paints:
Lime Yellow
Sky Blue
Sunflower

Brush:
Flat: 2"

Other Supplies:
Acrylic sealer, matte

INSTRUCTIONS

Prepare:
1. Refer to Surface Preparation on pages 6–10. Prepare clothes tree.

2. Using flat brush, base-coat pole and legs with Lime Yellow. Let dry.

Paint the Design:
1. Paint legs with Sky Blue.

2. Paint pegs with Sunflower.

Finish:
1. Apply several coats acrylic sealer.

The Zoo Headboard

Designed by
Alison Stillwell

GATHER THESE SUPPLIES

Project Surface:
Twin size wooden headboard

Acrylic Craft Paints:
Licorice
Light Fuchsia
Light Periwinkle
Lime Yellow
Orchid
Patina
Periwinkle
Purple Lilac
Sky Blue
Tangerine
Teddy Bear Tan
Yellow Light

Brushes:
Flat: 2"
Round: #6
Script liner: #1

Other Supplies:
Acrylic sealer, matte
Latex paint that matches:
 Warm White
Low-tack masking tape,
 2" wide
Transfer tools

INSTRUCTIONS

Prepare:
1. Refer to Surface Preparation on pages 6–10. Prepare headboard.

2. Using flat brush, base-coat all surfaces with several coats latex paint. Let dry.

3. Paint side poles with Lime Yellow.

4. Refer to photograph above as a guide. Evenly space and position masking tape on headboard.

5. Using flat brush, paint exposed areas with thinned Sky Blue. Remove tape and let dry.

Paint the Design:
1. Refer to How to Paint Your Project on page 11. Transfer animal patterns on pages 120–125 onto headboard.

Note: This is a great time to use your own imagination as you compose the position of the animals.

2. Refer to Decorative Painting on pages 12–21. Using round brush, paint elephants with Purple Lilac.

3. Paint giraffes with Tangerine. Add spots first with Teddy Bear Tan, then apply second coat with Orchid, letting some Teddy Bear Tan show on edges.

4. Paint lions with Patina. Paint mane with Patina plus Yellow Light.

5. Paint hippopotamus with Periwinkle, then apply second coat with Light Periwinkle, letting some Periwinkle show on edges.

6. Paint zebra with Light Fuchsia. Let dry. Paint stripes with Licorice.

7. Using script liner, outline and add details to animals with Licorice.

Finish:
1. Using flat brush, apply several coats acrylic sealer.

The Zoo Bedside Table

Pictured on page 117

Designed by
Alison Stillwell

GATHER THESE SUPPLIES

Project Surface:
Wooden end table

Acrylic Craft Paints:
Licorice
Light Fuchsia
Light Periwinkle
Lime Yellow
Orchid
Patina
Periwinkle
Purple Lilac
Sky Blue
Sunflower
Tangerine
Teddy Bear Tan Yellow Light

Brushes:
Flat: 2"
Round: #6
Script liner: #1

Other Supplies:
Acrylic sealer, matte
Latex paint that matches:
 Warm White
Low-tack masking tape,
 2" wide
Transfer tools

INSTRUCTIONS

Prepare:
1. Refer to Surface Preparation on pages 6–10. Prepare table.

2. Using flat brush, base-coat all surfaces with latex paint. Let dry. Paint tabletop and front panel with several coats.

3. Refer to photograph on page 117 as a guide. Evenly space and position masking tape on table.

4. Using flat brush, paint exposed areas with thinned Sky Blue. Remove tape and let dry.

5. Paint edge around tabletop with Lime Yellow.

6. Paint edges of table sides and shelf with Sunflower.

7. Paint supports on each side of table with Sky Blue.

8. Let all paint dry.

Paint the Design:
1. Refer to How to Paint Your Project on page 11. Transfer animal patterns on pages 120–125 onto table.

Note: This is a great time to use your own imagination as you compose the position of the animals.

2. Refer to Decorative Painting on pages 12–21. Using round brush, paint elephants with Purple Lilac.

3. Paint giraffes with Tangerine. Add spots first with Teddy Bear Tan, then apply second coat with Orchid, letting some Teddy Bear Tan show on edges.

4. Paint lions with Patina. Paint mane with Patina plus Yellow Light.

5. Paint hippopotamus with Periwinkle, then apply second coat with Light Periwinkle, letting some Periwinkle show on edges.

6. Paint zebra with Light Fuchsia. Let dry. Paint stripes with Licorice.

7. Using script liner, outline and add details to animals with Licorice.

Finish:
1. Using flat brush, apply several coats acrylic sealer.

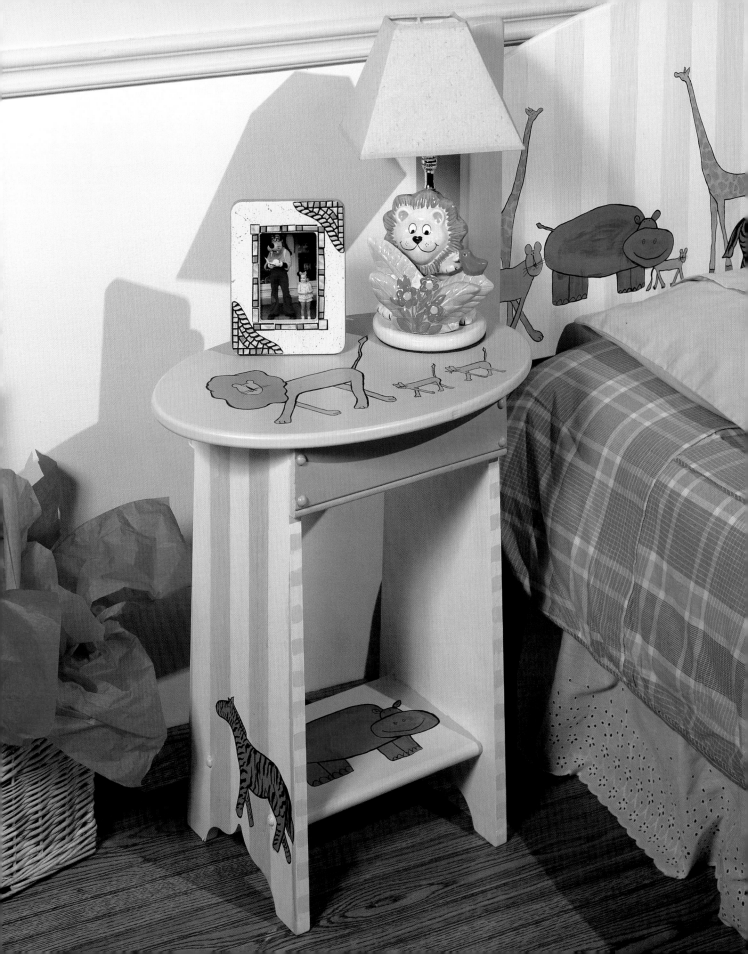

The Zoo Toy Chest

Pictured on page 119

Designed by
Alison Stillwell

GATHER THESE SUPPLIES

Project Surface:
Wooden storage chest

Acrylic Craft Paints:
Licorice
Light Fuchsia
Light Periwinkle
Lime Yellow
Orchid
Patina
Periwinkle
Purple Lilac
Sky Blue
Sunflower
Taffy
Tangerine
Teddy Bear Tan
Warm White
Yellow Light

Brushes:
Flats: 1", 2"
Round: #6
Script Liner: #1

Other Supplies:
Acrylic sealer, matte
Latex paint that matches:
 Warm White
Low-tack masking tape,
 2" wide
Pencil
Transfer tools

INSTRUCTIONS

Prepare:
1. Refer to Surface Preparation on pages 11. Prepare chest.

2. Using 2" flat brush, base-coat all surfaces with several coats latex paint. Let dry.

3. Refer to photograph on page 119 as a guide. Evenly space and position masking tape on chest lid.

4. Using flat brush, paint exposed areas with thinned Sky Blue. Remove tape and let dry.

5. Paint beveled edges around lid with Sunflower.

6. Paint sides of chest and bottom section of front with Lime Yellow.

7. Paint middle section of front with Taffy.

8. Using pencil, mark approximately 1½" checks around outer edge of front. Use eye to measure so that checks fit evenly around chest.

9. Using 1" flat brush, paint checks with Sunflower.

Paint the Design:
1. Refer to How to Paint Your Project on page 11. Transfer animal patterns on pages 120–125 onto chest.

Note: This is a great time to use your own imagination as you compose the position of the animals.

2. Refer to Decorative Painting on pages 12–21. Using round brush, paint elephants with Purple Lilac.

3. Paint giraffes with Tangerine. Add spots first with Teddy Bear Tan, then apply second coat with Orchid, letting some Teddy Bear Tan show on edges.

4. Paint lions with Patina. Paint mane with Patina plus Yellow Light.

5. Paint hippopotamus with Periwinkle, then apply second coat with Light Periwinkle, letting some Periwinkle show on edges.

6. Paint zebra with Light Fuchsia. Let dry. Paint stripes with Licorice.

7. Using script liner, outline and add details to animals with Licorice.

Finish:
1. Using flat brush, apply several coats acrylic sealer.

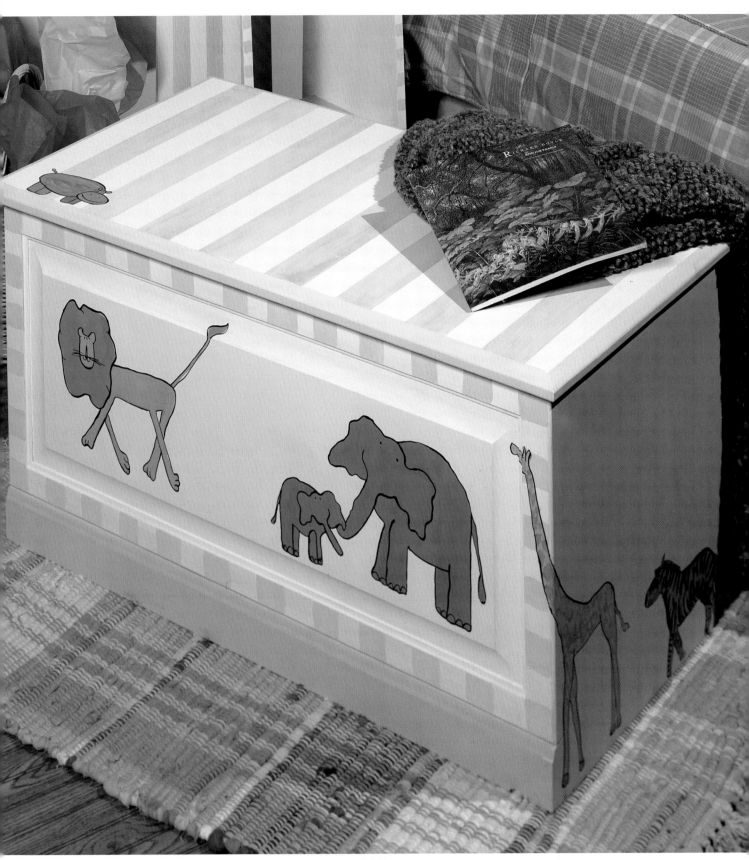

The Zoo Large Giraffe Pattern

The Zoo Large Hippopotamus Pattern

Product Source

FolkArt® Paints referred to as Acrylic Craft Paints in this book:
Acorn Brown #941
Apple Spice #951
Aspen Green #646
Autumn Leave #920
Baby Blue #442
Barnyard Red #611
Basil Green #645
Bayberry #922
Berry Wine #434
Blue Ink #642
Butter Pecan #939
Buttercream #614
Buttercup #905
Cappuccino #451
Christmas Red #958
Clay Bisque #601
Clover #923
Coffee Bean #940
Country Twill #602
Dapple Gray #937
Dark Plum #469
Emerald Isle #647
English Mustard #959
Evergreen #724
Fresh Foliage #954
Grass Green #644
Gray Green #475
Gray Plum #468
Green Forest #448
Green Meadow #726
Heather #933
Holiday Red #612
Holly Leaf #228
Honeycomb #942
Huckleberry #745
Hunter Green #406
Indigo #908
Italian Sage #467
Ivory White #427
Lemon Custard #735
Lemonade #904
Licorice #938
Light Blue #402
Light Fuchsia #688
Light Periwinkle #640
Lime Yellow #478
Linen #420
Lipstick Red #437
Maple Syrup #945

Midnight #964
Mushroom #472
Night Sky #443
Nutmeg #944
Old Ivy #927
Olive Green #449
Orchid #637
Parchment #450
Patina #444
Periwinkle #404
Poppy Red #630
Portrait Light #421
Purple Lilac #439
Purple Passion #638
Purple #411
Raspberry Wine #935
Real Brown #231
Rose Chiffon #753
Shamrock #926
Skintone #949
Sky Blue #465
Spring Rose #767
Sterling Blue #441
Sunflower #432
Taffy #902
Tangerine #627
Tapioca #903
Teal Green #733
Teddy Bear Tan #419
Thicket #924
Thunder Blue #609
Wicker White #901
Wrought Iron #925

FolkArt® Artists' Pigments™ referred to as Acrylic Craft Paints in this book:
Alizarin Crimson #758
Aqua #481
Asphaltum #476
Burnt Carmine #686
Burnt Sienna #943
Burnt Umber #462
Dioxazine Purple #463
Hauser Green Light #459
Hauser Green Medium #460
Medium Yellow #455
Napthol Crimson #435
Payne's Gray #477
Pure Black #479

Pure Orange #628
Raw Sienna #452
Raw Umber #485
Red Light #629
Titanium White #480
Turner's Yellow #679
Warm White #649
Yellow Light #918
Yellow Ochre #917

FolkArt® Metallic Acrylic Colors:
Antique Gold #658
Inca Gold #676

Decorator Glazes:
Neutral Glazing Medium
New Gold Leaf Glaze

FolkArt® Products:
Floating Medium #868
Crackle Medium #695
Glass & Tile Medium #869
Glazing Medium #693
Frost It™ #220

Finishes:
FolkArt® Artists' Varnish
 Gloss #882
 Satin #885
 Matte #888

FolkArt® Outdoor Sealer #891
Clearcote™ Matte Acrylic Sealer #789
FolkArt® Water-base Varnish #792

Applicators and Tools:
Decorator Tools™
 Spatter Tool #30121
Decorator Tools™
 Ocean Sponge #31050
Decorator Tools™
 Chamois Tool #30130
Spouncer™ ¾" #1533
Tip-Pen™ by Plaid®

Stencil DÈcor Products:
Stencil brushes, various sizes
Stencil Blank Material #26667

Stencils:
Simply® Stencils
Checkerboard Collection #28771
Simply® Stencils
 Moroccan Border #28836

Apple Barrel® Gloss Enamels referred to as Indoor/Outdoor Acrylic Paints in this book:
Antique White #20623
Arbor Green #20653
Beachcomber Beige #20663
Bermuda Beach #20643
Black #20662
Coffee Bean #20666
Cranberry Red #20633
Crown Gold #20647
Dandelion Yellow #20646
Deep Purple #20625
Dolphin Grey #20624
Forest Green #20649
Goodnight Blue #20661
Hot Rod Red #20637
Lanier Blue #20656
Lavender #20356
Mocha #20665
Mossy Green #20648
Pink Rose #20631
Pinwheel Blue #20657
Purple Velvet #20627
Raspberry #20629
Real Blue #20660
Real Red #20636
Real Yellow #20645
Spring Green #20652
Tangerine #20639
White #20621

Metric Conversion Chart

MM-Millimeters CM-Centimeters

INCHES TO MILLIMETERS AND CENTIMETERS

INCHES	MM	CM	INCHES	CM	INCHES	CM
⅛	3	0.3	9	22.9	30	76.2
¼	6	0.6	10	25.4	31	78.7
½	13	1.3	12	30.5	33	83.8
⅝	16	1.6	13	33.0	34	86.4
¾	19	1.9	14	35.6	35	88.9
⅞	22	2.2	15	38.1	36	91.4
1	25	2.5	16	40.6	37	94.0
1¼	32	3.2	17	43.2	38	96.5
1½	38	3.8	18	45.7	39	99.1
1¾	44	4.4	19	48.3	40	101.6
2	51	5.1	20	50.8	41	104.1
2½	64	6.4	21	53.3	42	106.7
3	76	7.6	22	55.9	43	109.2
3½	89	8.9	23	58.4	44	111.8
4	102	10.2	24	61.0	45	114.3
4½	114	11.4	25	63.5	46	116.8
5	127	12.7	26	66.0	47	119.4
6	152	15.2	27	68.6	48	121.9
7	178	17.8	28	71.1	49	124.5
8	203	20.3	29	73.7	50	127.0

Index